Wild Cactus

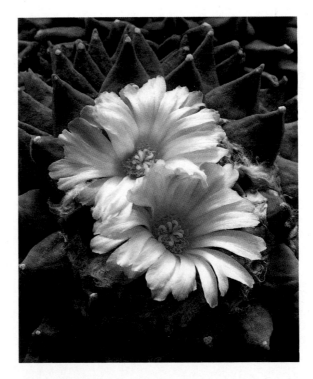

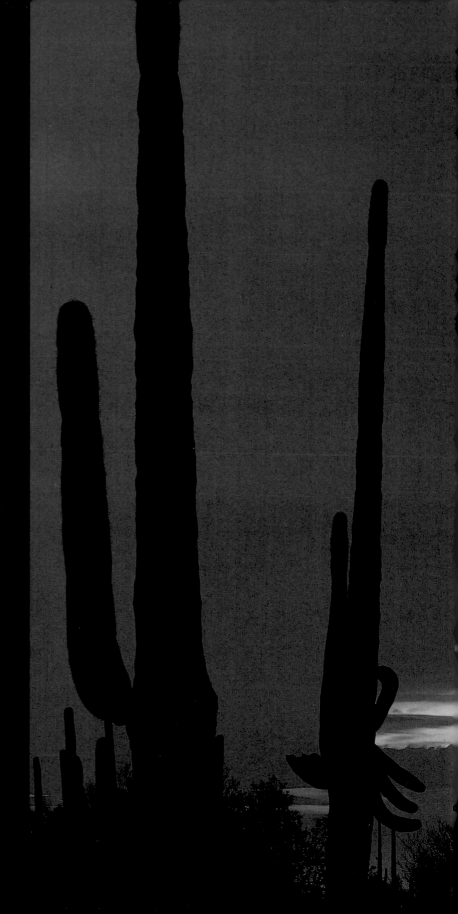

ARTISAN · NEW YORK

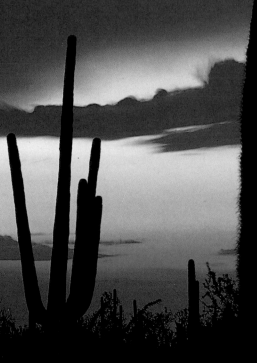

Wild Cactus

Photographs by
George H. H. Huey

Text by Rose Houk
Foreword by Gary Paul Nabhan

PRODUCTION DIRECTOR Hope Koturo

Published in 1996 by Artisan
a division of Workman Publishing Company, Inc.
708 Broadway, New York, NY 10003

LIBRARY OF CONGRESS CATALOGING-IN-PUBLICATION DATA
Huey, George H. H.
Wild Cactus / photographs by George H. H. Huey; text by
Rose Houk.
p. cm.
ISBN 1-885183-20-8
1. Cactus—Southwest, New. 2. Cactus—Southwest, New—
Pictorial works. I. Houk Rose, 1950– . II. Title.
QK495.C11H84 1996
583' .47—dc20 95-47808

PAGE 1
Living rock cactus (*Ariocarpus retusus* var. *furfuraceus*),
Chihuahuan Desert, Mexico
PAGES 2—3
Saguaro cactus (*Carnegiea gigantea*), west side of Saguaro
National Park outside Tucson, Arizona
PAGE 5
Detail of pad of prickly pear cactus (*Opuntia engelmannii*)
with penstemon
PAGE 6
CLOCKWISE FROM TOP LEFT: Beavertail cactus (*Opuntia
basilaris*), Zion National Park, Utah; brown-flowered cholla
cactus (*Opuntia alcahes*) on Isla Espiritu Santo in the Sea
of Cortez, Mexico; Texas prickly pear cactus (*Opuntia
engelmannii* var. *texana*) in Big Bend National Park, Texas;
fishhook barrel cactus (*Ferocactus wislizeni*) and gila monster,
Saguaro National Park, Arizona
PAGE 7
TOP: Senita cactus (*Lophocereus schottii*), Vizcaino Desert,
Baja California, Mexico
BOTTOM: Hedgehog cactus (*Echinocereus engelmannii*),
Mason Valley, Anza-Borrego State Park, California

Printed in Italy
10 9 8 7 6 5 4 3 2 1
First Printing

The cacti, overcoming rigors

that offer only a slender

margin for life, are

considered one of the great

successes of the plant world.

—Edward Abbey, *Cactus Country*

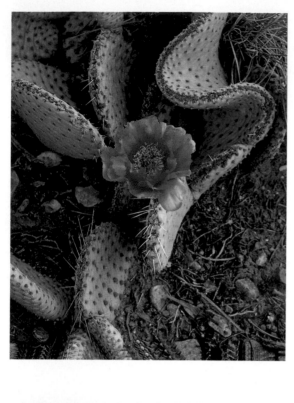

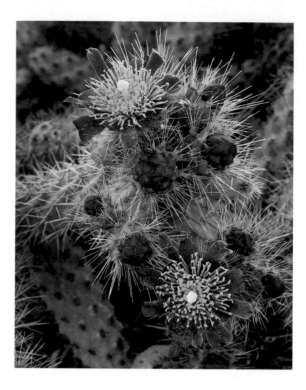

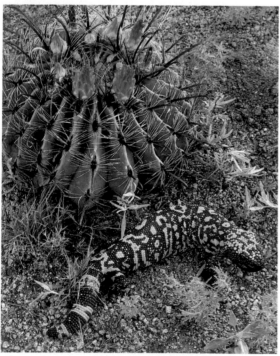

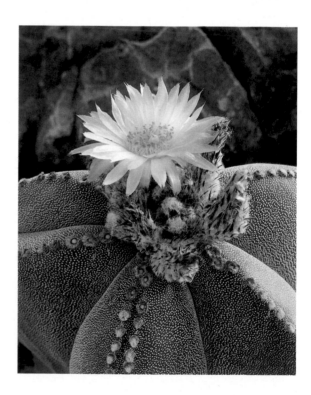

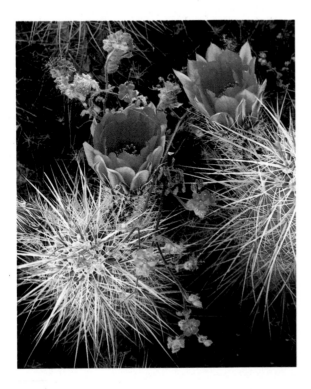

Contents

8 FOREWORD
by Gary Paul Nabhan

11 INTRODUCTION
A Rose in Disguise

37 NATURAL HISTORY
Midnight Blooms

55 ETHNOBOTANY
Cactus for Mind and Body

75 HISTORY OF DISCOVERY
The Cactus Chronicles

99 HUMAN IMPACT
AND CACTUS CONSERVATION
Disappearing Acts

APPENDIX

119 Growing Your Own

122 Pronunciation Guide

123 Select Sources

124 Acknowledgments

125 Index

Foreword
Gary Paul Nabhan

Whenever i grow tired of cities, canned food, and potted plants, I go back to visit a desert oasis just south of the Arizona border with Sonora, Mexico. There, an ancient desert people have lived for centuries in houses that have the dried ribs of saguaro cactus for walls, and organ pipe cactus wood bundles for ceilings. The indigenous people living there continue to eat several kinds of prickly pear fruit when they are freshly ripe. Each person gathers fifty to one hundred pounds of organ pipe fruit every summer, and their families boil this harvest down into a delicious jam. They make wine of saguaro fruit, a tender vegetable dish out of cholla cactus buds, and a treatment for diabetes out of the tubers of night-blooming cereus.

It is not too much of a stretch to claim that these people's very cells are merely the transformed cells of cactus flowers, fruit, stems, and roots. It is also not too surprising that the same people sing of cactus in their traditional music and refer to particular columnar cacti as "other kinds of people," not too distantly related to themselves.

There is another village in a distant desert—at the eastern edge of the Chihuahuan Desert in the Mexican state of Tamaulipas—that seems to be shaped entirely out of cactus. Its streets are all lined with living rows of Mexican fence-post cactus, hedges of impenetrable cholla, and thickets of arborescent prickly pears. Even though Western botanical scientists might claim that the cultivated prickly pears there are all one species, the local peasants give them eighteen different names and classify them by their fruit colors, their sweet or sour aftertastes, their ripening times, their relative thornlessness and seediness. Each of these cultivated varieties has its own way of breaking the monotony of the local diet, of adding a distinctive seasonal flavor to a larder dominated by corn and beans. For a few weeks every year, each kind of fruit stains the sidewalks with its own brilliant color, as if marking its own spot on the traditional calendar.

For the last 8,000 years of life in American deserts, cacti have been a nutritional mainstay, a cultivated crop and a wild harvest, and a source of medicine, music, and magic. Unfortunately, there are now Native- and Mexican-American

children in many cities in the United States who literally do not know that prickly pears are edible, for they have been isolated from what was once their grandparents' greatest sources of sustenance. Many European-Americans lack this knowledge as well, assuming that something so thorny must be more of a pest than a feast. An indifferent society is more likely to let rare cacti disappear within its midst, and this is indeed what we see happening from the southwestern United States, clear down to the Atacama Desert in Peru and Chile.

While lack of contact with the natural world is more and more prevalent among us, there are countertrends which give us hope. The small windowsill displays of potted cacti popular in the 1960s have now given way to expanded cactus gardens, greenhouses, and landscape plantings throughout the United States, Latin America, Europe, and Japan. And while a portion of cactus trade still draws upon plants of undocumented or dubious origin, more and more are grown from seed, cuttings, or tissue culture without depleting wild populations. Cactus enthusiasts are now becoming more active advocates for habitat conservation, realizing that all the potted plantings in the world cannot save a species from ecological extinction—that is, the extinction of its natural relationships with pollinators, seed dispersers, root fungi, and nurse plants. And finally, we are seeing the careful reintroduction of rare cacti into restored habitats where they can be protected enough to proliferate.

In short, many people are bringing cacti back into their lives in innovative and interesting ways, preferring them to the insipid green of manicured lawns or to the engineered uniformity of conventional house plants. In fact, we might be bold enough to claim that the famed Green Revolution is finally over, for we are no longer as interested in introducing lush plants to the deserts as we are in sustaining native desert cacti within their original habitats. Let us now raise the banner of the Spiney Revolution, one that gives both cacti and cactus-lovers their due. And let us now praise famous prickly pears, barrels, hedgehogs, organ pipes, claret cups, and others of their kind, ensuring that they will remain alive not only in our imaginations and our gardens, but in *their* habitats as well.

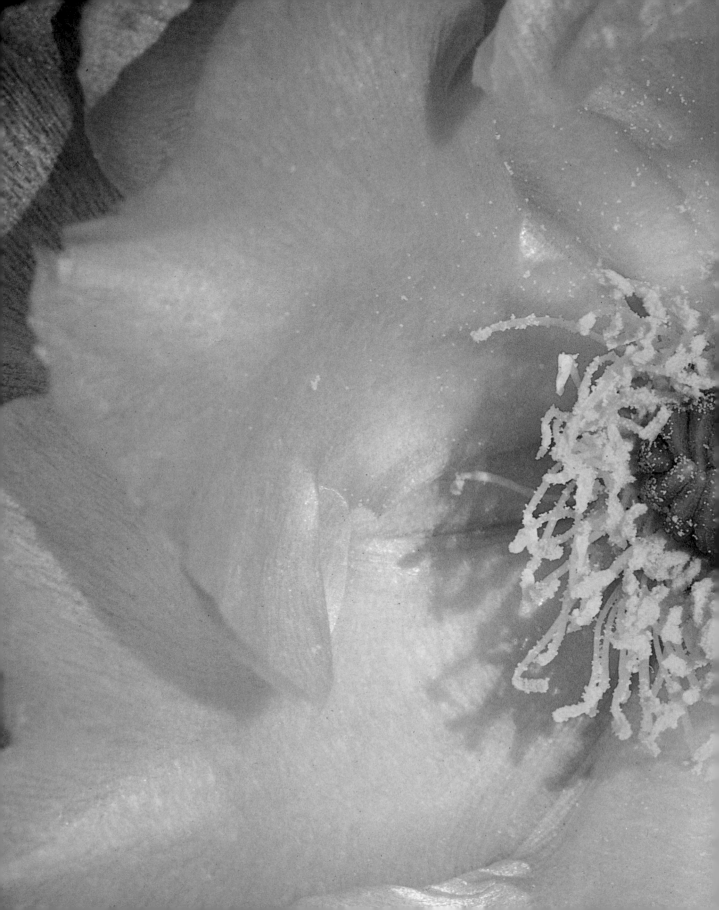

A Rose in Disguise

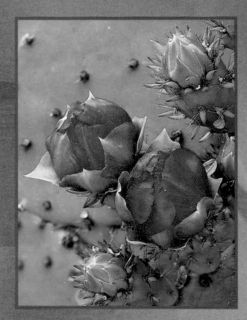

A Rose in Disguise

A STEADY, SOFT, GRAY RAIN had been falling for two days in southern Arizona. Alamo Creek was roaring full with muddy brown foam. The redolence of wet creosote bushes richened the air. Ocotillo were sprouting leaves before my eyes. Silver waterfalls poured off the rusty cliffs of the Ajo Mountains. The rubbled ground was saturated.

Could this possibly be the desert? A place defined not by the presence of water, but by its absence? A place more familiar as a rocky, sun-baked wasteland, home to lurking rattlesnakes, wily roadrunners, and spiny cacti?

Yet on this Christmas Day in Organ Pipe Cactus National Monument, the predominant sense was of green. Every living thing was taking advantage of the sudden abundance of water. Saguaro cacti and prickly pears and chollas were swollen nearly to bursting, their expandable tissues gorging on the moisture that would sustain them throughout the parched months ahead. Tiny water droplets hung from the tips of each spine, dripping onto the plants' thirsty roots.

I had come to see the famous organ pipe cactus, for which the national monument was named. Here, only a few miles north of the Mexican border, the species reaches nearly its farthest northern limits. I wasn't disappointed. There were many fine specimens with multiple, graceful stems rising from the base of each plant, the raised ribs lined with neat clusters of dark spines. Approaching for a closer look, I walked gingerly around each plant, for the ground was littered with cholla joints waiting to insinuate their vicious spines into the soles of my boots. Amassed in the center of each organ pipe was an impenetrable mound of more cholla joints, most certainly imported by industrious pack rats armoring their nests.

I had also come to see the senita, or old man cactus, another species that finds the warmer climate of Mexico more to its liking. A small population of senita can be reached by dirt road within the park, but the road was closed due to the rains. No senita on this trip.

Like the most dedicated birders, seeking yet one more species for their life lists, cactus lovers are willing to travel great distances to see rarities. But why? What

PRECEDING PAGES: *Prickly pear cactus* (Opuntia phaecantha) *flower.* INSET: *Prickly pear cactus* (Opuntia engelmannii *var.* texana). ABOVE: *Jumping cholla* (Opuntia fulgida). OPPOSITE: *Prickly pear cactus* (Opuntia phaecantha) *in fruit with saguaro cactus and ocotillo in the background, on a rainy morning in Saguaro National Park, Arizona.*

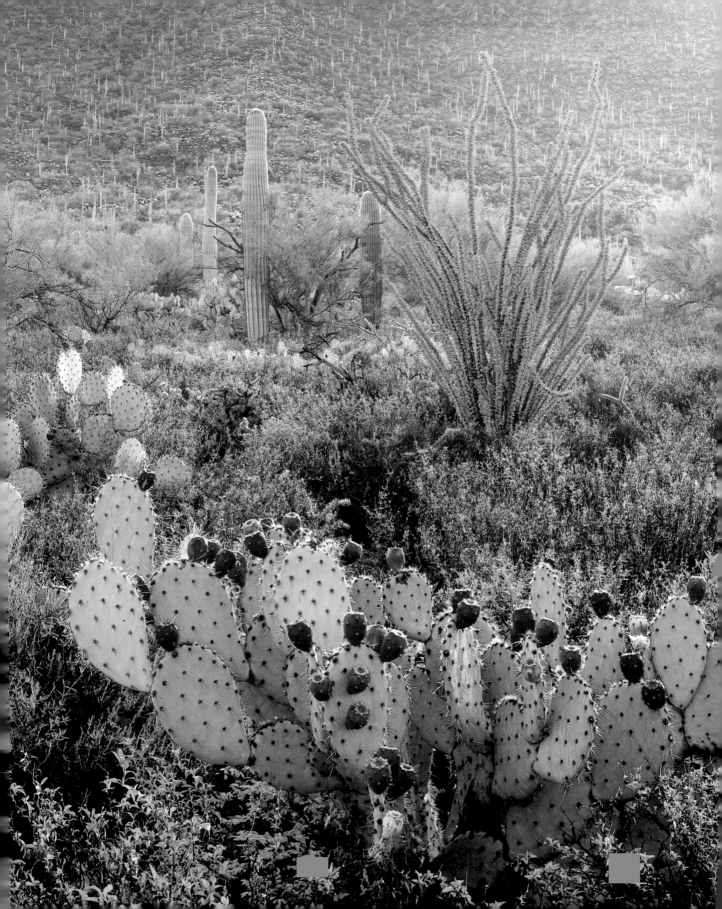

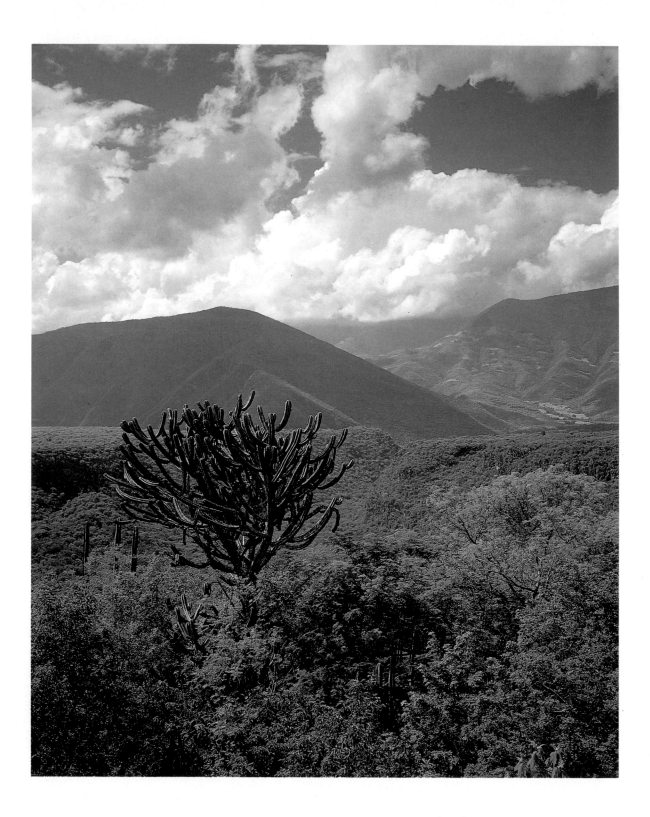

is it about these plants that so piques our interest? Perhaps it is their bizarre shapes, their lovely flowers, their clever adaptations.

The Cactaceae, as the family is known, are almost exclusively a New World group. Cacti originated in southern Mexico and northern South America, and they now reach greatest development in the central highlands of northern Mexico.

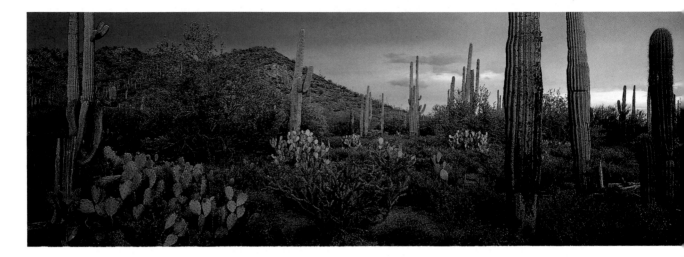

OPPOSITE: Myrtillocactus geometrizans *grows in the high, wet environment of the Sierra Gorda, in the state of Queretaro, Mexico. This cactus reaches tree size and is increasingly cultivated for its edible berry.* ABOVE: *A classic Sonoran Desert scene in the heart of the cactus belt: different-aged saguaros, chollas, and prickly pears form a lovely cactus garden in Saguaro National Park in southern Arizona.*

CACTI GROW in all kinds of places—not only deserts, but also beaches, mountains, grasslands, and even in the branches of trees in the tropics. Some are exceedingly specialized: one grows only on prehistoric shell mounds in Florida, the only high, dry ground for miles, another on a single mudflat in Mexico. Cacti can be found from sea level to above 10,000 feet elevation, and over an immense range: from the east coast to the west coast of the United States cacti are native in every state except Maine, New Hampshire, Vermont, Alaska, and Hawaii, from as far north as the Peace River in central Canada to the tip of Argentina, and in the Caribbean Islands.

Despite this incredible diversity of habitat and range, plant ecologist Forrest Shreve long ago observed that cacti "really belong somewhere in the desert, where the big outdoors is just a little bigger than it is anywhere else." Shreve defined a "cactus belt" for the United States, extending 1,200 miles from central Texas to the mountains on the western edge of the Mojave Desert in California. Cacti grow in all four of the North American deserts: the Chihuahuan, the Mojave, the Great Basin, and the Sonoran.

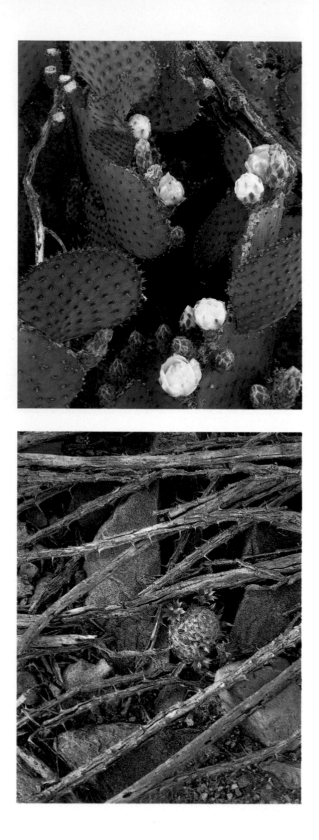

TOP: *The purple pads are a distinctive feature of the Santa Rita prickly pear* (Opuntia violacea var. santa-rita). *The color can vary seasonally depending on temperature. The appealing hue has made this prickly pear a popular cactus for desert landscaping. The name comes from the Santa Rita Mountains south of Tucson, Arizona, where it is common.*

BOTTOM AND OPPOSITE: *The little Arizona fishhook cactus* (Mammillaria microcarpa) *is often found sheltered among rocks or woody stems. The genus name* Mammillaria *derives from the tubercles on the stems. Flowers of* Mammillaria *arise on the side of the plant rather than on the top.*

FOLLOWING PAGES: *Saguaro* (Carnegiea gigantea) *and cholla* (Opuntia fulgida) *in the Ajo Mountains near the Arizona-Mexico border.*

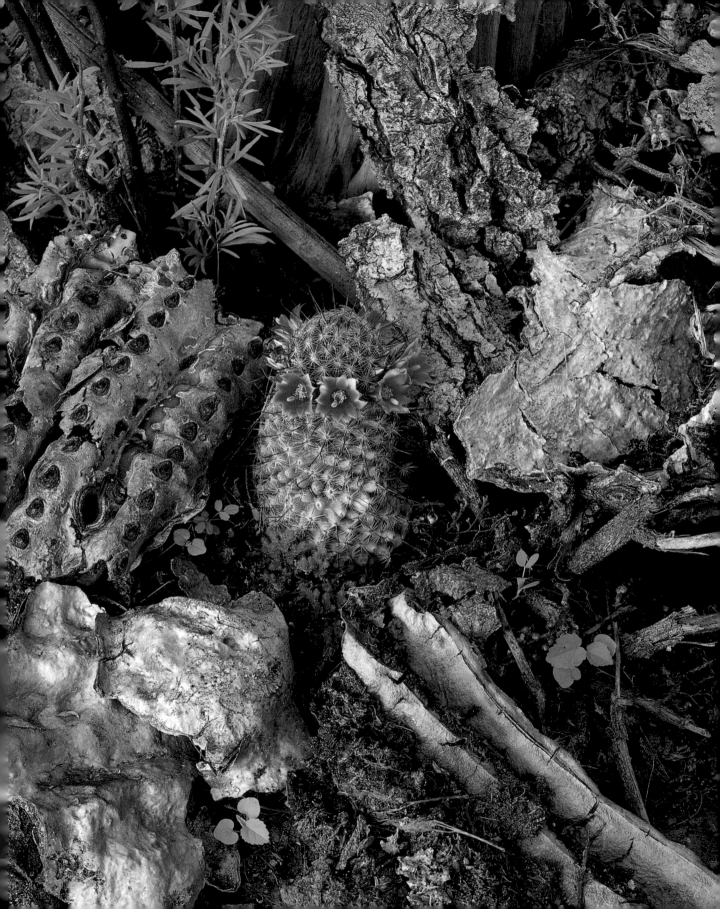

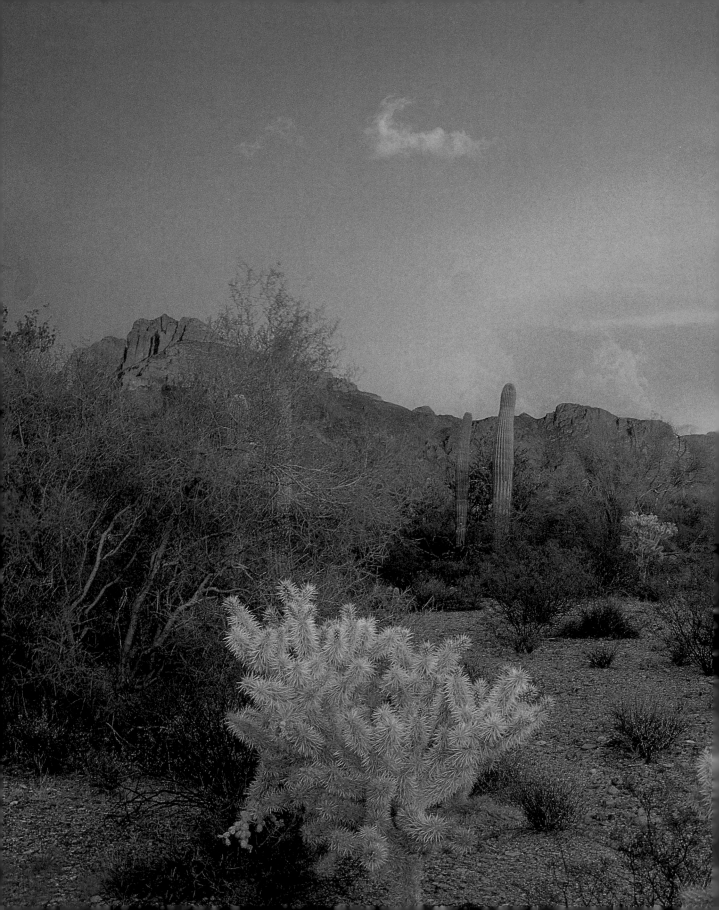

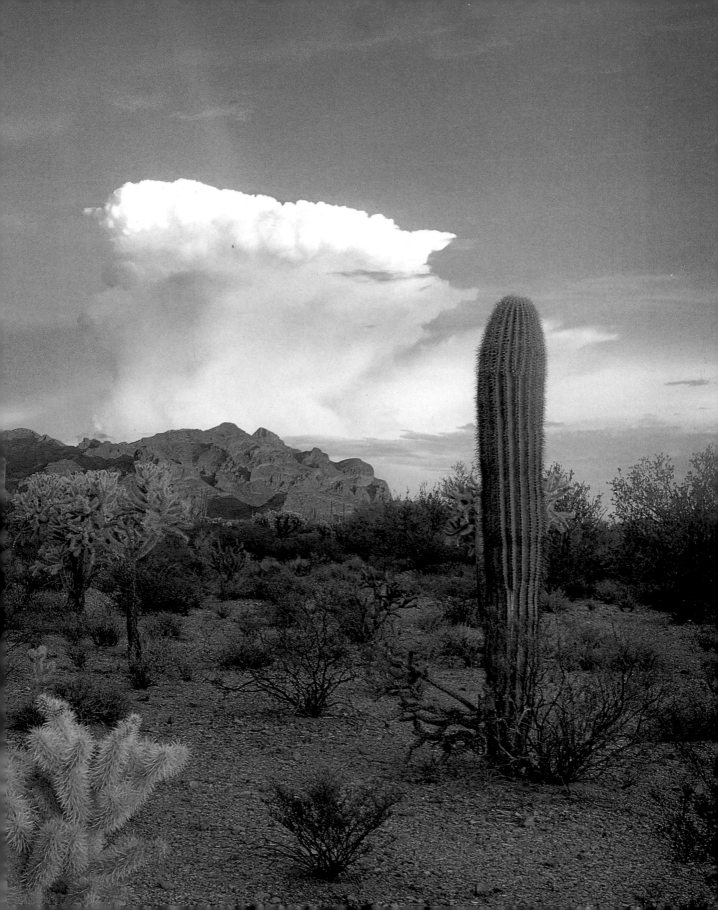

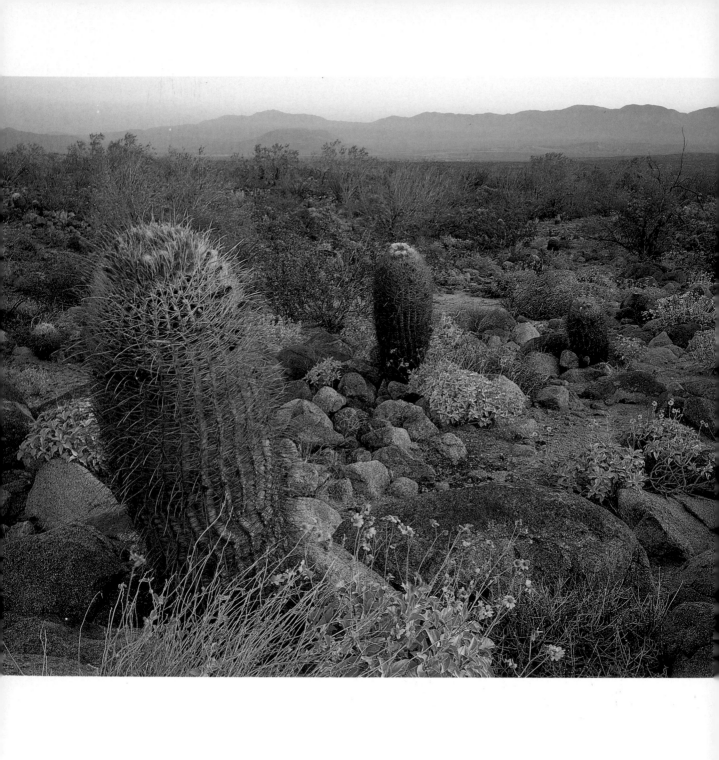

The Chihuahuan Desert is a land of limestone daggered with yuccas. Most of this desert lies in Mexico, sandwiched between the two branches of the Sierra Madre, with only a thumb intruding into the United States. It boasts the greatest variety of cacti, with especially impressive ones along the border in the Big Bend country of the Rio Grande, in the Guadalupe and Franklin mountains in Texas, and in southern New Mexico. The Chihuahuan cactus inventory includes diminutive, ground-hugging pincushions, coryphanthas, and *Ariocarpus,* or living rock cactus, all camouflaging well against the pale limestone bedrock of the Chihuahuan country. Claret cup cacti are especially outstanding when they flower in spring, their bright orange and red blooms shining like beacons on the hillsides.

Within this desert I had my first encounter with cacti, in the Pecos country of west Texas, home of legendary Judge Roy Bean. A tenderfoot tourist, shod in sandals, I'd walked out a few feet across the gravelly soil. Immediately a curved spine penetrated my bare heel, teaching me a quick lesson in proper footwear for cactus country. Later, over near Big Bend, a tanned, long-haired man eagerly informed us that peyote grew nearby. His wild-eyed stare intimated that perhaps he'd already sampled a bit too much of this vision-inducing cactus.

The boundaries of the Mojave Desert are notched on the east by Saint George, Utah, cutting through the middle of Joshua Tree National Park to the south, and grading into the Great Basin Desert on the north. The Mojave collects rain mostly in winter from storms rolling in from the Pacific. The sweeping valleys

are filled with endless stretches of creosote bush and bursage, while the trademark Joshua tree, a member of the yucca family, is found on the moister edges of the Mojave. Among the cacti to be found in the Mojave are the many-headed barrel, the beavertail prickly pear, the stunning Mojave hedgehog, and gardens of Bigelow's cholla in Joshua Tree National Park.

The Great Basin Desert occupies a big chunk of Nevada, Utah, a small part of northwestern New Mexico, and the corner of northeast Arizona. Cacti are not particularly diverse or numerous in this high, cold land of sagebrush valleys, salt-laden dry lakes, and gorgeous canyons, but a few can be found: chollas, prickly pears, hedgehogs, small barrels in the genus *Sclerocactus,* along with some interesting, rare *Pediocactus.*

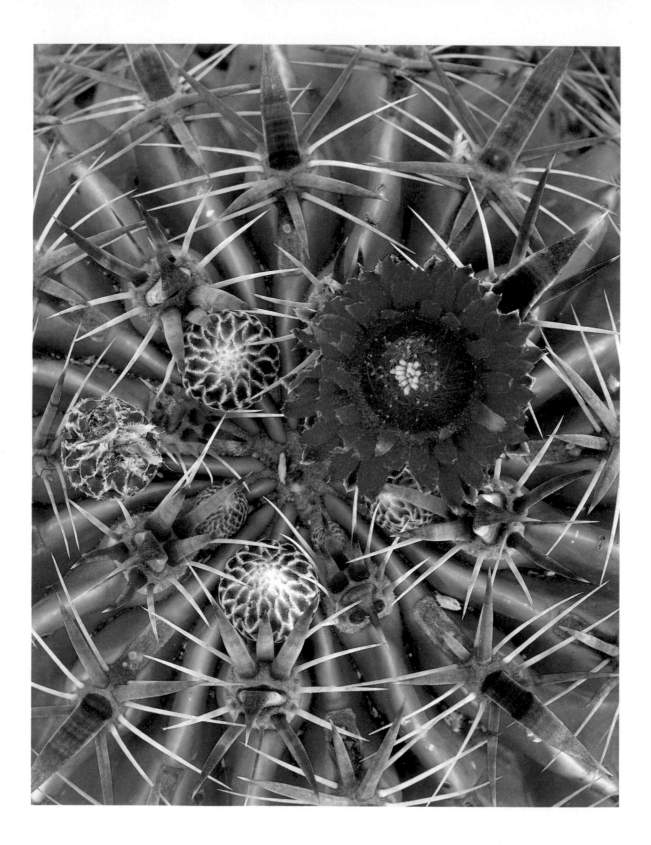

OPPOSITE: *Barrel cactus*
(Ferocactus latispinus).
CLOCKWISE FROM TOP
RIGHT: *Hedgehog cactus*
(Echinocereus engelmannii)
in the Vallecito Mountains in
Anza-Borrego State Park in
California; eagle claw cactus
(Echinocactus horizon-
thalonius) *in Big Bend*
National Park, Texas; a
pincushion cactus (Mammil-
laria hahniana). *The barrel*
cactus, opposite, and the eagle
claw and pincushion are cacti
of the Chihuahuan Desert.

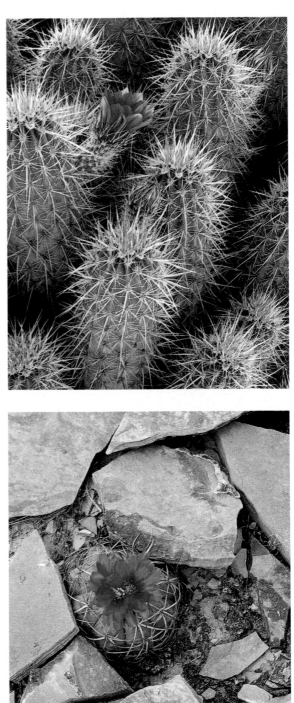

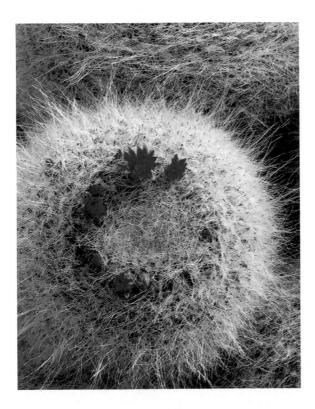

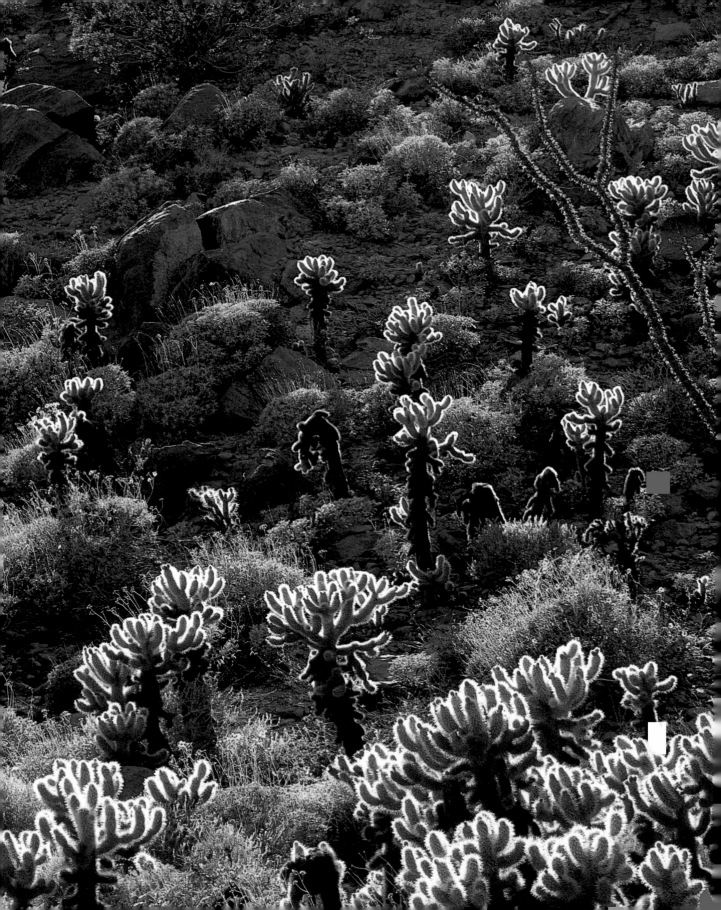

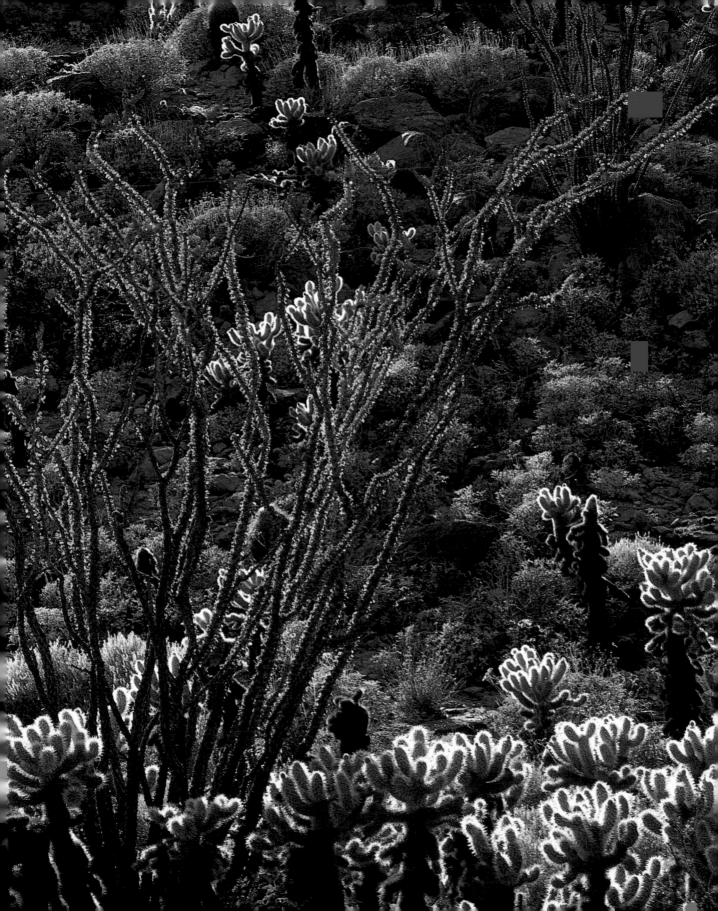

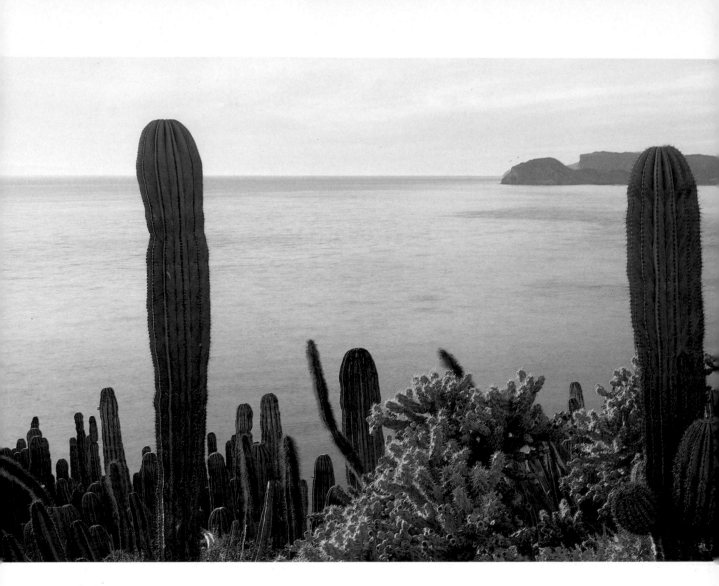

Many would agree the most spectacular cactus display appears in the Sonoran Desert, which stretches southward from Phoenix, Arizona, into Sonora, Mexico, and Baja California. Nourished by winter and summer rains, the Sonoran is botanically the most diverse of the four North American deserts. It is known as an "arborescent" desert, for the tree-sized saguaro cactus that fairly marks its bounds. This magnificent member of the vegetative kingdom, with a distinctly humanoid shape, has been silhouetted against fiery western sunsets in countless photographs.

Wherever they are found, cacti exhibit extremely diverse growth habits. They vary in size and shape from one about the size of a fingernail, to the mushroom-

PRECEDING PAGES: *Teddy bear cholla* (Opuntia bigelovii) *and ocotillo in full spring bloom in the Mojave Desert of Anza-Borrego State Park, California. Although they do bear thorns, ocotillos are not cacti and belong to a different plant family.*

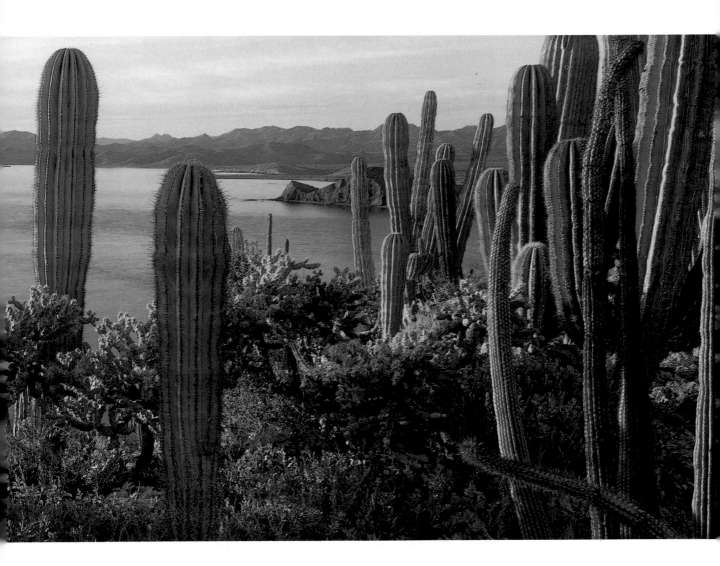

ABOVE: *A rich collection of cacti, including magnificent cardons* (Pachycereus pringlei), *thrives on the slopes of Isla Cholludo in the Sea of Cortez. Although cardons and saguaros look much alike, saguaros are not found in Baja California.*

like peyote, about the size of a quarter, to vines, and to treelike forms more than fifty feet high. Stems may be cylindrical, flat, ribbed, nippled, or pleated like an accordion, either single, clustered, or branched. Some cacti stand out in isolation on otherwise barren ground. Others are so cryptic they blend in perfectly with the stony desert pavement.

Although botanists frown on common names because they are often regional and confusing, for cacti the vernacular is delightfully descriptive: beehive, birdfoot, beavertail, grizzly bear, eagle claw, corncob, pineapple, gearstem, and horse crippler, to mention a few. Meanwhile, botanists have bestowed proper Latin names

A pitaya agria (Steno-
cereus gummosus) *sprawls*
across a ridgetop of the Sier-
ra de la Giganta, a moun-
tain range in south-central
Baja California, Mexico.
This large cactus is domi-
nant in much of Baja Cali-
fornia and is a relative of
pitaya dulce, *the organ pipe*
cactus. The white flowers of
both species open for only
one night.

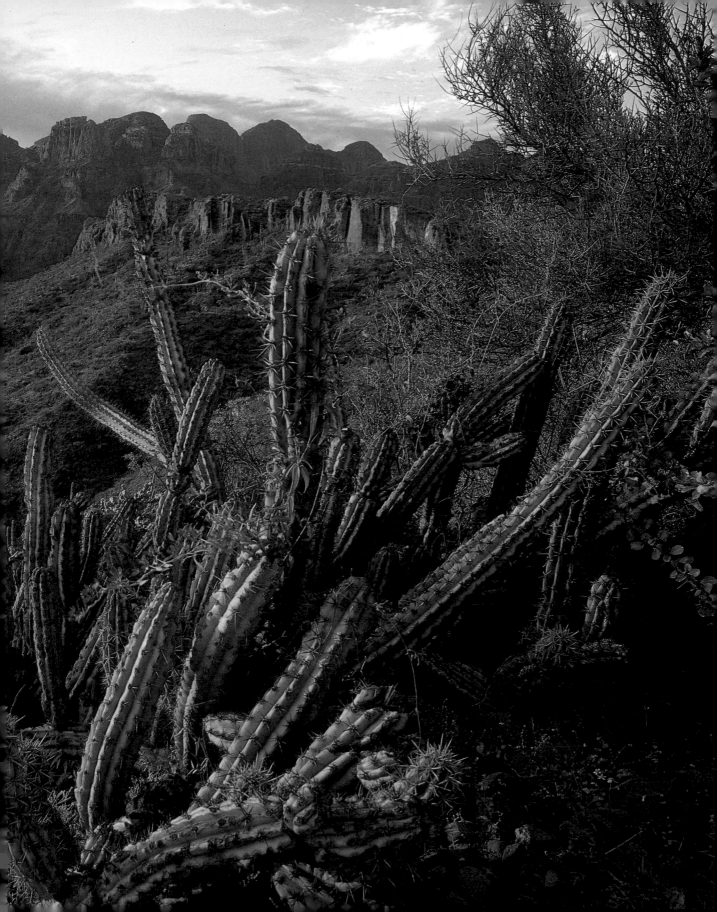

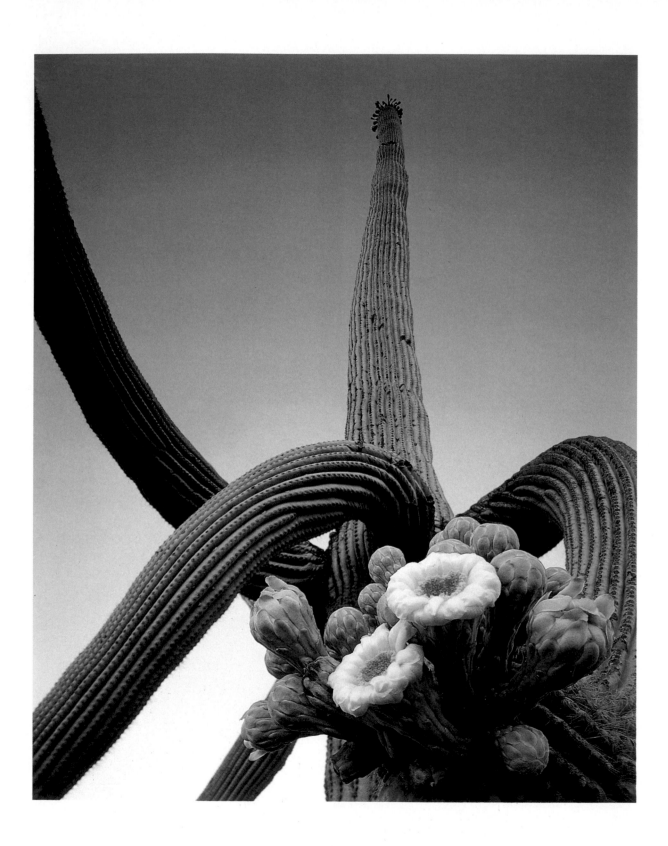

to more than 1,500 (some count 2,000) species of cacti in the world. Though species can be difficult to tell apart without a microscope, the most common cacti fit generally into a handful of basic groups: prickly pears and chollas, barrels, hedgehogs, pincushions, and the columnar species such as the saguaro, Mexico's cardon, and Chile's guillave.

The botanical ancestry of cacti is murky at best. Forrest Shreve believed their closest relatives are violets, passion flowers, and begonias. Some botanists see kinship with the ice plant, the carnation, and the portulaca. Yet others say they share a common ancestor with saltbush and spinach.

As with all plants, flowers provide the best clues to establishing this lineage. What attracts most people to cactus flowers, however, is simply their breathtaking beauty. The blooms shine like jewels, their metallic sheen splashing the land with outrageous magentas, fuchsias, clarets, yellows, and oranges. In his classic 1930s book *The Fantastic Clan,* John James Thornber insisted "you have not seen Life ... till you have viewed at least once the wondrous parade of the brilliant cactus flowers, and surveyed the gorgeous painted canvas flung far out over the burning mesas on the Great American Desert." These flowers are so admired that botanical gardens have hotlines for people to call for the latest update on spring and summer blooming times.

Curiously, people often apply judgmental adjectives to the poor cactus: odd, weird, strange, grotesque, bizarre, forbidding, even lurid and evil. Yet these are, after all, plants, not people. Such pejoratives are undeserved, for cacti are not evil so much as downright ingenious in adapting to the various environments in which they live. Almost all except a few tropical species have eliminated leaves to save water. Succulent stems serve as water-storage reservoirs, and spines shade the plants and keep them from being eaten. A waxy outer skin and special metabolism also help them endure heat and dryness.

Cacti deserve praise for their starring ecological roles. They feed and house all sorts of birds, insects, and mammals. For thousands of years, humans have drawn on the wealth of cacti, finding both sacred and secular uses for the fruits, pads, buds, spines, and roots.

Many people do admire the good points of cacti, for they view, photograph, and collect them; cultivate them indoors and out; and join associations devoted to them. When I lived in Tucson, Arizona, I became especially enamored of the giant saguaros surrounding the city, hoping one day to see a bumper sticker that read: "Have You Hugged a Saguaro Today?"

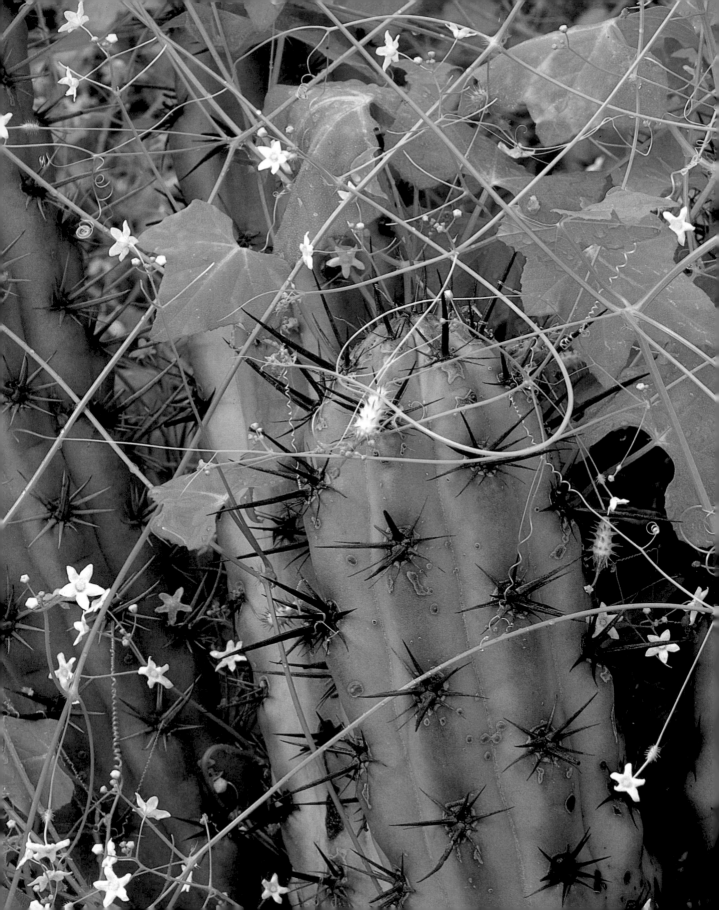

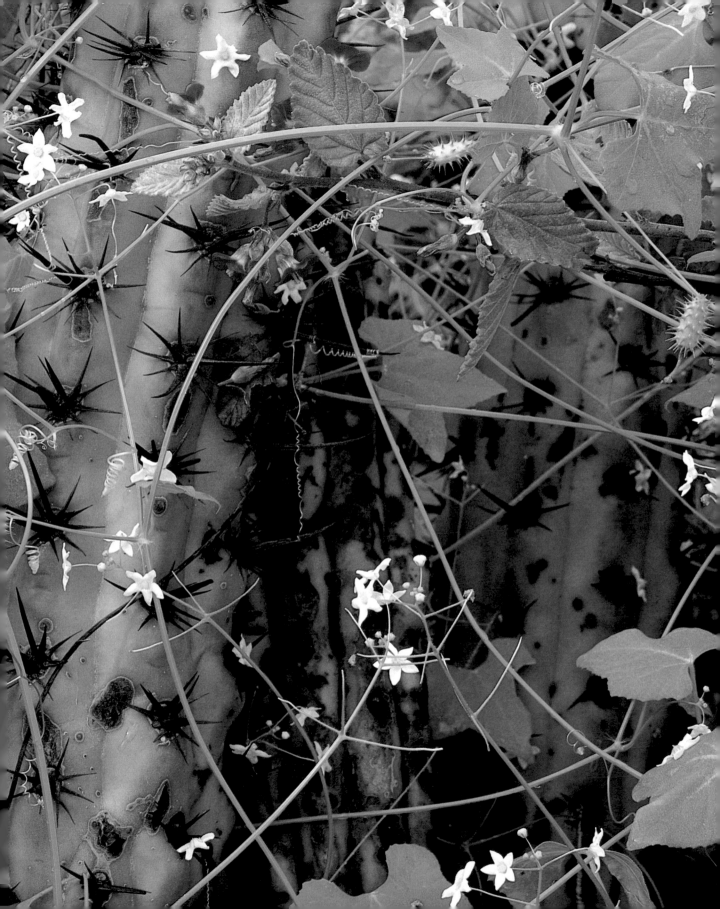

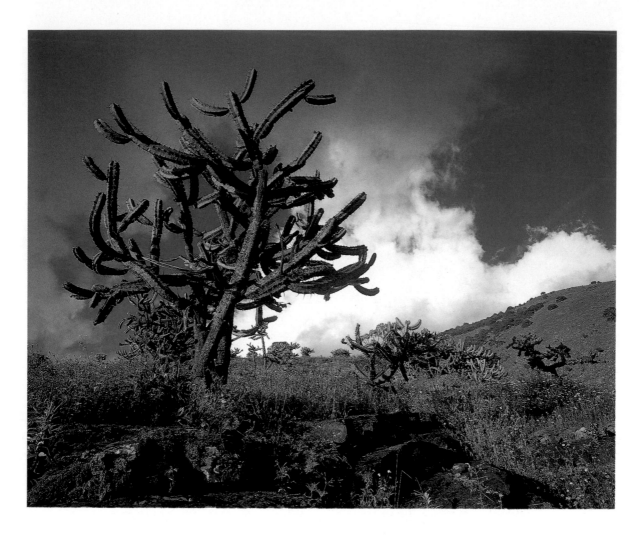

This desirability has in some cases proved detrimental to cacti. Unrestricted collecting has wiped out local populations of rare species and brought others to the brink of extinction. Because certain species command high prices, cactus rustlers have become the West's new outlaws. Most states and many countries now prohibit any collecting of cacti from the wild, and tight restrictions are in place to control the international trade. The other major threat, perhaps the most insidious, is the ongoing destruction of the habitat of cacti in the name of progress.

To be able to marvel at a display of cacti in their native home, as I was privileged to do on that magical Christmas in Organ Pipe Cactus National Monument, is a gift.

ABOVE: *The fruits of* Myrtillocactus geometrizans *are known in Mexico as* gambullos. *The blue berries are eaten fresh and dried.* OPPOSITE: *The tubular stems of organ pipe cactus* (Stenocereus thurberi) *rise from the base of the plant like the pipes of a church organ.*

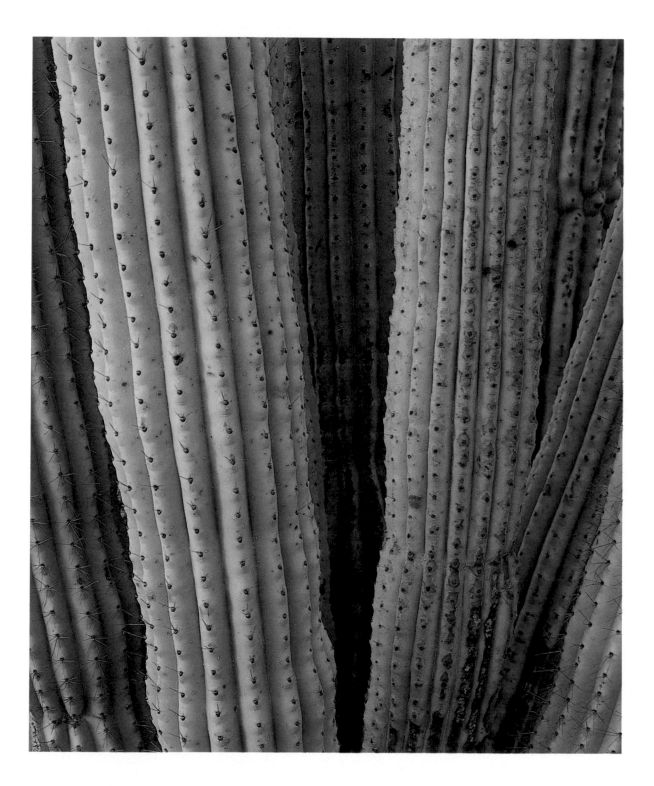

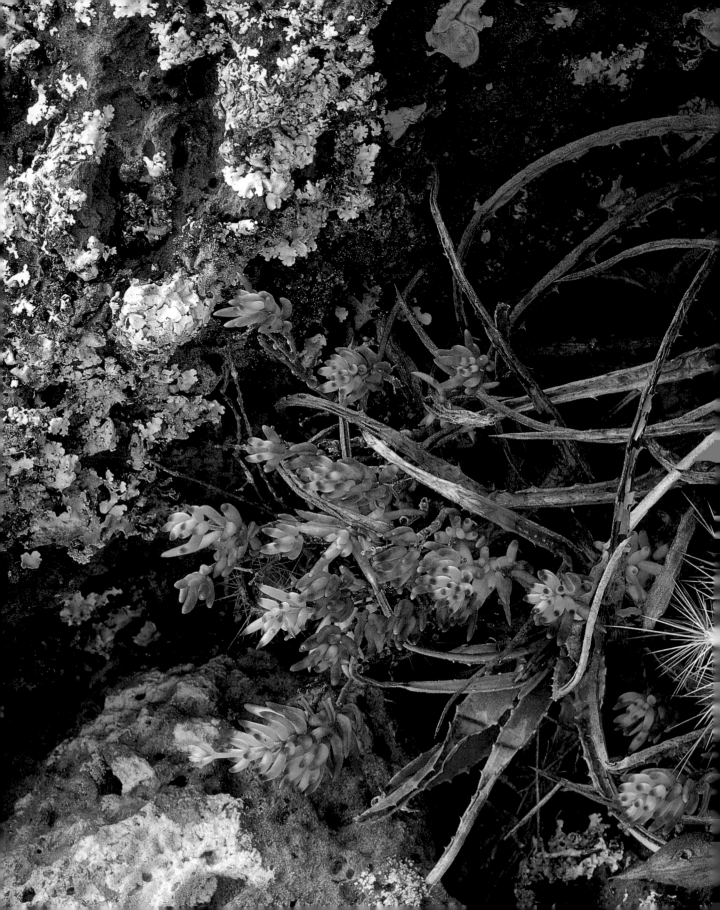

Midnight Blooms

Midnight Blooms

ON A WARM NIGHT IN JUNE, a spicy fragrance permeates the velvet desert air. The seductive scent emanates from the flower of a cactus called *reina de la noche,* queen of the night. The luminous white blossom grows from a stalk that is an excellent mimic of a dull gray stick. In fact, that's what *reina de la noche* looks like most of the year, growing inconspicuously beneath the shade of a creosote bush or a mesquite tree. Except on that special night when it comes out of hiding and adorns itself with exquisite, sweet-smelling flowers.

Initially a bud grows slowly, but a few days before blooming, the bud signals its readiness by putting on a spurt of growth. The petals on the large trumpet-shaped flower of this cereus actually can be seen unfolding. The flower lasts only one night, and each plant blooms only once in a season.

The fragrance, likened to freshly gathered spices, can be detected from a good distance away. Nocturnal flowers such as these don't need color to draw nectar-feeding pollinators such as bats and moths, but they do need fragrance. A huge underground tuber, a turniplike structure weighing up to a hundred pounds, furnishes the energy that lets the night-blooming cereus put on this annual display.

Reina de la noche and all other cacti have one trait in common: structures called areoles. The areole is what makes a cactus a cactus. Other similar succulent or thorned plants such as ocotillo, yucca, and agave lack areoles, and thus do not share membership. Areoles appear as circular spots scattered at random over the pads and joints, or marching up and down the ribs.

An areole is the growth point on cacti, the place where leaves, flowers, and spines appear. Although not all cacti have spines, most do. In fact, the word cactus derives from the Greek *kaktos,* for a spiny plant. Cactus spines may be erect, curved, hooked, round, flat, stiff, bristly, wooly, hairy, or papery. The chollas have sheathed spines. A central spine is often longer or hooked, surrounded by shorter radial spines. Spines come in white, ivory, yellow, brown, red, or almost black. The rainbow cactus is named for the bands of different-colored spines that spiral around the stem. The color, shape, number, and arrangement of spines is useful in diagnosing species of cacti.

PRECEDING PAGES: *A seedling of* Stenocereus dumortieri *sprouts from a rock crevice.* INSET: *Night-blooming cereus* (Peniocereus greggii). ABOVE: *Spines of a senita cactus* (Lophocereus schottii). OPPOSITE: *The glorious miracle of the flowering of* reina de la noche *is a much anticipated event on warm summer nights in the desert.*

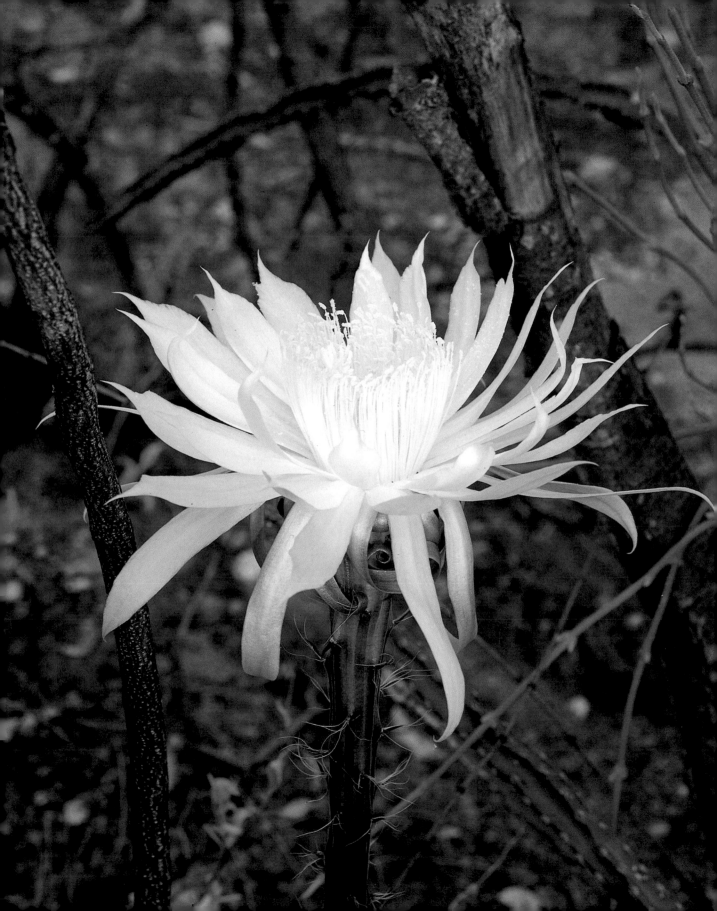

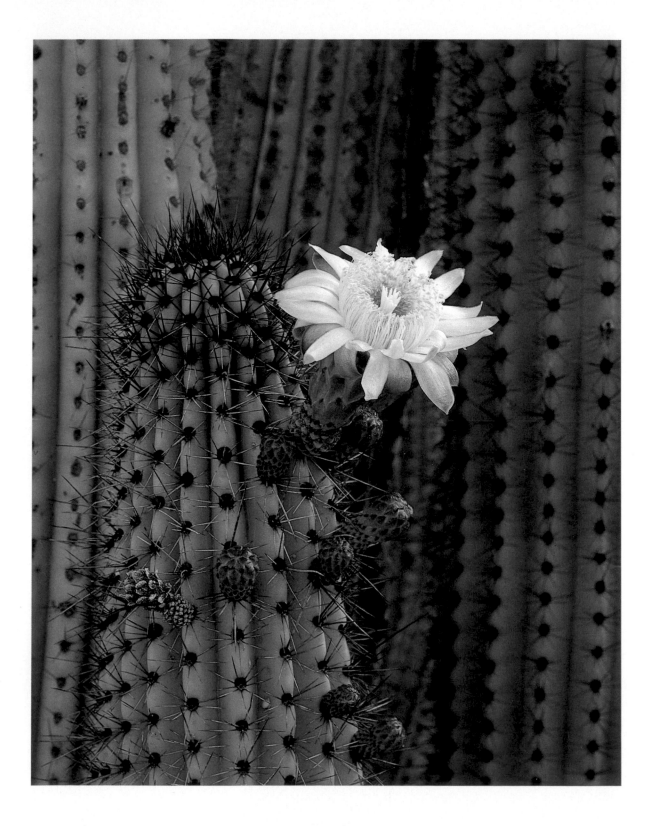

Spines are not part of the plant tissue, but instead are easily detached. Anyone who's gotten too close to a cactus can testify without hesitation to this feature. The *Opuntias* (prickly pears and chollas) also possess mean little hairy bristles called glochids that are almost impossible to see but not to feel. "The aim of their existence," declared Forrest Shreve, "seems to be ultimately to reach the fingers." The blind prickly pear, which has only glochids and no spines, has earned its common name because the glochids blow into the eyes of cattle and blind them.

For cacti, spines serve important functions: they help insulate the plant by lowering temperature and protecting them from damaging radiation; deter some hungry animals; and mitigate the effects of drying winds. (More than one desert lover, camped near a saguaro, swear they've heard music when the wind blows through the spines.) Spines are so numerous and dense on some cacti that the green stems are almost hidden. Father Johann Jakob Baegert, perhaps bored with his duties as a Jesuit priest in Baja California, counted the spines on a hand-sized section of an organ pipe cactus: there were "no less than 1,680," from which he extrapolated that "a single one of these shrubs carries more than a million thorns."

On some cacti, looks can deceive. The translucent spines of the teddy bear cholla appear soft as fur. Walking one day with a friend who was new to the desert, I watched in horror as she reached down and picked up a teddy bear joint before I could stop her. She never made that mistake again. Those individual loose joints have, incidentally, proved a successful reproductive technique among cholla and their relatives, the prickly pears. The joints and pads fall to the ground and root there—bypassing sexual reproduction for the "easier" vegetative method.

Like spines, flowers also arise from areoles. Flowers may appear up and down the ribs of cacti, individually at the end of a stem, or as a wreath encircling the top of the plant. Sometimes a cactus must attain great age before it begins to flower. A saguaro, for example, will be around forty years old before producing large, creamy white flowers.

In the Southwest, the season of bloom varies among the different groups of cacti. The best flowering time begins in April and May and lasts into August and September. Some cacti bloom at night, others just after sunrise, still others only in the afternoon. One observer found he could practically set his watch by the blossoming of the jumping cholla. Between 2:30 and 3:00 in the afternoon—and not a minute sooner—the flowers would open. In years of good winter rains, when

Organ pipe cactus (Stenocereus thurberi) *blooms from June to September in the warmest parts of the Sonoran Desert. As with other night-blooming cacti, the organ pipe cactus is pollinated by moths and bats. The flowers almost always close at sunrise. Hummingbirds sip the sugary drops that collect on the flower buds.*

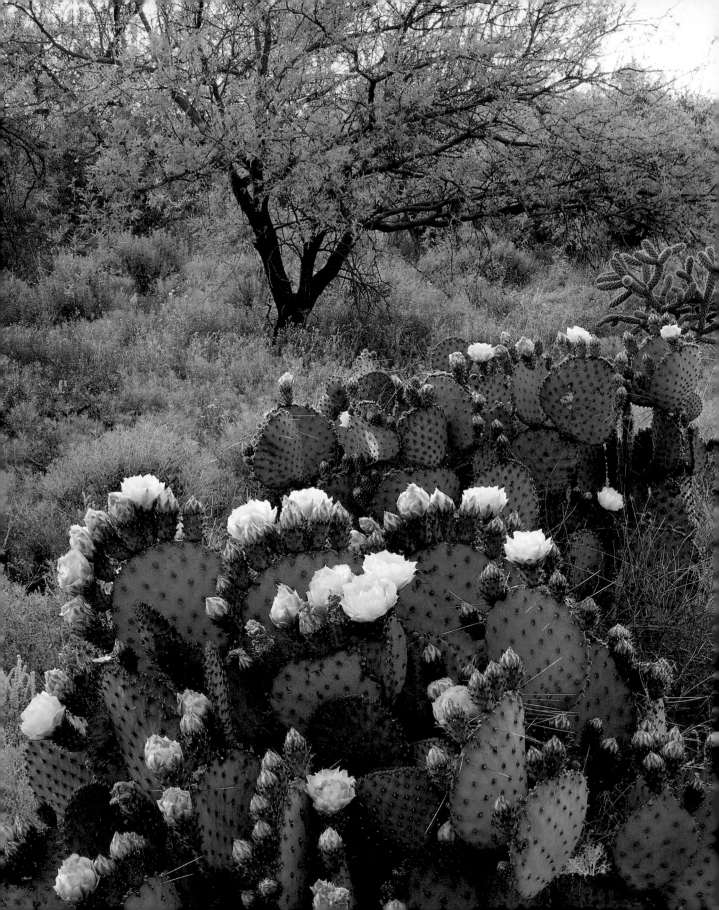

OPPOSITE: *Yellow flowers of the Santa Rita prickly pear* (Opuntia violacea var. santa-rita) *bloom abundantly from April to June. The pollen-loaded stamens within the flowers are an open invitation to bees and other insects to indulge in this food source. This healthy specimen grows in the Sierrita Mountains south of Tucson, Arizona.* ABOVE LEFT: *Saguaro trunk with globe mallow.* ABOVE RIGHT: *Jumping cholla skeleton with gold Mexican poppies and owl clover.*

wildflowers such as California poppies, lupines, and penstemons join in, the desert is a fiesta of color. Cacti, which are perennials, are not as dependent on these rains to assure their bloom. Because they can store water, some flower even in years of poor rainfall.

The big broad flowers of cacti have many petals and sepals. They also have many stamens, sometimes hundreds or thousands of them. Stamens bear pollen, which means cacti have a great deal of pollen to spread around. When a bee, for instance, approaches and lands, the sensitive stamens actually move, thus ensuring that some pollen falls on the unwary courier. You can see this happen simply by placing your finger close to the dusty stamens of an open prickly pear flower.

Should a bee, bird, or bat purvey some yellow male dust from one flower to another, an ovule may be fertilized and a fruit will begin to develop. The fleshy fruits of cacti are often red or maroon, the better to attract birds and insects which eat the pulp and help disperse the many tiny black seeds within.

Once a seed lands on fertile ground, and temperatures are in the ninety-degree range, a seed may germinate. At this tender seedling stage, a cactus is most

vulnerable. In fact, most require a "nurse plant" to shelter them during this time, when a long drought or quick freeze could end their short lives.

The nurse plant may be a tree, a shrub, or even a grass. Often in the desert, a saguaro is seen growing up through a palo verde tree, which succored the cactus during its younger years. Hedgehog cacti known as claret cups often rely on salt-bushes, wherein lies an interesting story. Biologists have studied claret cups in White Sands National Monument in southern New Mexico and found that moist moss beneath saltbushes provides fine germination beds for the cactus seeds. Once sprouted, the slow-growing seedlings (they grow only about an inch a year) are shaded by the shrubs. But it's a plant-eat-plant world out there. The claret cups' shallow roots vie with the saltbushes for precious water, and in most cases the claret cups win. Their nurse saltbushes eventually die from lack of water.

Cacti can survive a long time without water, but they cannot do so indefi-nitely. To deal with this fact of life, cacti have evolved several ways to store and conserve water. These masterful adaptations explain how they have succeeded in some of the most arid places in the world. Perhaps most important—and most obvious upon seeing cacti for the first time—is that they've done away with leaves. (The "primitive" *Pereskia* and *Pereskiopsis* are the only cacti that possess leaves. New cholla joints and prickly pear pads also sport a few fleshy, tiny leaves, but they are soon dropped.) Leaves are lavish water users in any plant; thus, getting rid of them significantly saves water. Instead of leaves, the stems of cacti take over the work of making food and exhaling water vapor.

Having succulent stems means that water can be stored in the plant tissue and called upon when needed. The cactus makes deposits when it rains, and with-drawals when it needs to grow and produce flowers and fruit. Among the tall saguaros and cardons, water may account for up to ninety percent of their weight—and for an eight- to twelve-ton plant, that amounts to tons of water upon which the cactus can survive for a year or two. In addition, cactus stems are cov-ered with a waxy epidermis that reduces evaporation from the surface.

Underground, cacti are also working to capture as much water as possible. The roots of most species lie only inches beneath the surface of the soil. In the columnar cacti, for example, fleshy roots extend at most only about three feet down, but can stretch a hundred feet in all directions. Cacti also hurry and put out deciduous roots just after a rain to hasten absorption. When dryness returns, these

A tree cholla (Opuntia imbricata) *grows beneath branches of a mesquite tree in New Mexico's Sacramento Mountains. Mexican botanist Hernando Sanchez-Mejorada once said, "Nearly every cac-tus has its own madrina," or godmother, a nurse plant that protects a young cactus against temperature extremes and grazing animals.*

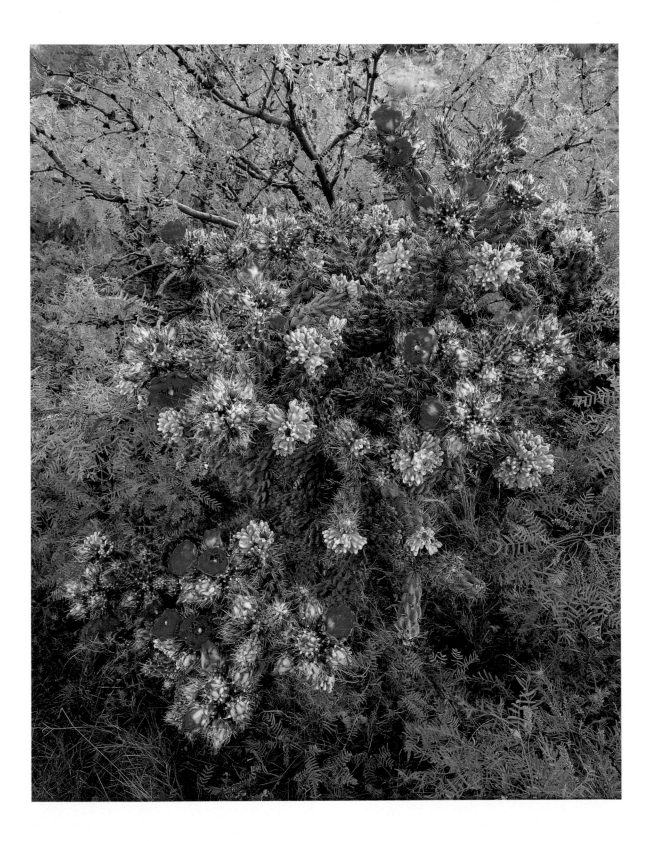

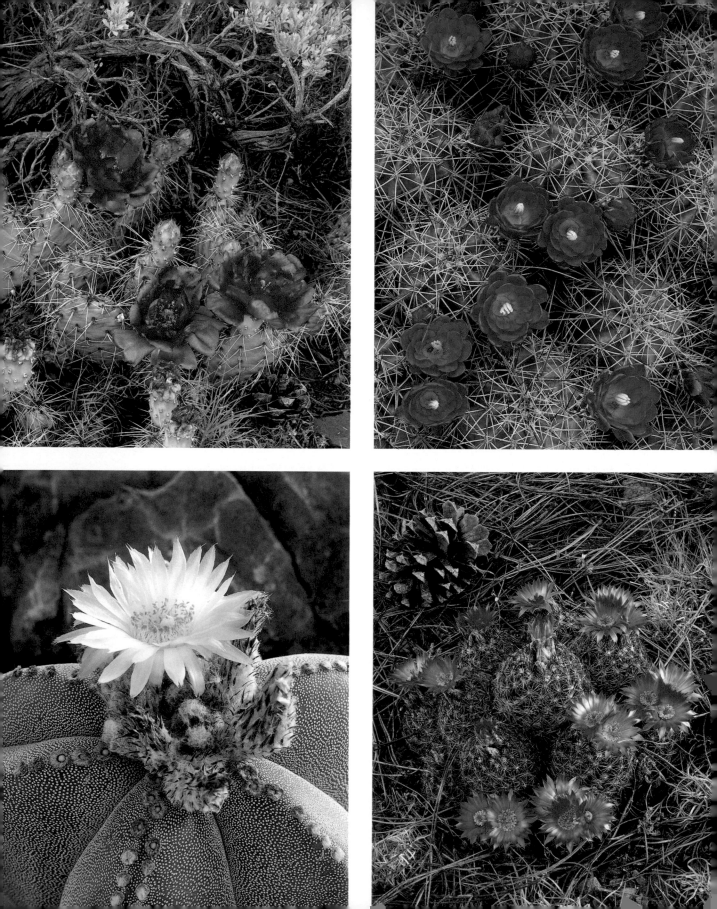

"rain roots" drop off. Shallow roots allow cacti to take advantage of even a light rain. But for the tall, heavy saguaros and cardons, such superficial roots have a disadvantage—high winds can topple them.

Like all green plants, cacti must photosynthesize to make food. Making food also means losing water, because pores (more properly, stomates) on the stems must be open for gas exchange. Cacti cleverly avoid this problem by following a two-step path: they open their large stomates at night to take in carbon dioxide, then fix and store the CO_2 until daytime, when the sun is shining and photo-synthesis can proceed. It's pleasant to camp in the desert on a moonlit night and think about all those cacti, busily performing their tricks of endurance while we sleep.

Special photosynthesis, spines, succulence, waxy skin: all work together to assure that cacti live admirably in the desert. But these same solutions are employed by other widely separated, unrelated plants as answers to the same problems. The concept is known as convergent evolution. A challenging exhibit at the Arizona-Sonora Desert Museum outside Tucson illustrates this principle. The display of live plants asks the viewer to guess which ones are cacti and which aren't: the similarities between African euphorbias and New World cacti are so great I'm stumped every time.

All these specialized adaptations in many isolated corners of the world have resulted in a high number of endemic cacti, found only in certain places and nowhere else. A striking example is a giant barrel cactus that grows on Isla Santa Catalina, a beautiful island off the coast of Baja California in the Sea of Cortez. While barrel cacti, or bisnaga, are known from many locations, a variety of Ferocactus diguetii, the giant barrel, grows only on Isla Santa Catalina. Its scientific name is for Leon Diguet, a Frenchman who discovered this cactus while searching offshore for pearls. Impressive individual specimens of this barrel can reach ten feet in height. In fact, Baja California is famous for the number of endemic cacti: nearly eighty of the peninsula's 110 species of cacti are found only there.

Whether endemic or widespread, wherever cacti occur they serve vital functions in their ecological community. Many kinds of birds rely on cacti for food, perches, and nest sites. On even a short walk along a desert wash or trail, you may see a nest ensconced within the silver-spined branches of a teddy bear cholla. Roadrunners, thrashers, and verdins find safe shelter among the branches, but the nest likely belongs to a cactus wren, a bird that lives almost exclusively in cholla.

Their bulbous nests are built from the inside out with a lining of soft feathers and a framework of woven grass and twigs. Most are decoy or "dummy" nests in which the wrens roost; only one usually serves as the primary nest where the birds lay eggs and raise young.

The architecture of the nest helps the wrens stay cool in their hot environment. The small tunnel-like opening is oriented to the southwest, so prevailing winds can circulate freely through the nest. An evaporative cooling effect results when hot winds blow over the moist fluids of the birds' wastes inside the nest.

Mammals also use cholla, dining on their thorny joints. Naturalist Ruth Kirk observed a jack rabbit employing an interesting technique to avoid the wicked spines. The animal placed its mouth between the spines, then held the upper jaw stationary while it scraped the pulp with the lower jaw. Pack rats also depend heavily on cacti. In the driest times, cacti account for ninety percent of their diet, providing not only nutrients but also valuable moisture. White-tailed deer and bighorn sheep also browse on cacti.

Peccaries, or javelinas, bite off cholla joints too, as well as the fruits of prickly pear and barrel cactus. But it is the pads of prickly pear that these piglike animals especially favor. Herds of javelinas move through, chomping sizable chunks out of the green pads, apparently undeterred by the spines; they reportedly have been seen pulling spines out of each other's snouts. A modification of their kidneys allows javelinas to excrete the poisonous oxalic acids in cacti, thus letting them eat a steady diet of the plants. The northward extension of the peccary's range from the tropics into the desert Southwest may have been possible because of their ability to cope with the acids in prickly pear.

In the Galapagos Islands, giant tortoises eat *Opuntias*. To avoid their foraging, the cacti have adapted by growing to tree size, some reaching fourteen feet in height.

Many columnar cacti—organ pipes, saguaros, and cardons—also serve as hosts to animals. When in flower and in fruit, organ pipes are the scene of an all-night orgy. Long-nosed bats dip deep into the flowers for nectar, taking both fruit and seeds, thus helping spread the plant to other sites. Moths enter the holes in

ABOVE LEFT: *Cactus wren in jumping cholla (Opuntia fulgida). The wrens build their bag-shaped nests deep within the protective armor of the cactus joints, insuring safe haven for their young from predators.* BELOW: *Even in death, a cactus provides habitat for insects such as this praying mantis, tiptoeing along a lacy cholla skeleton.*

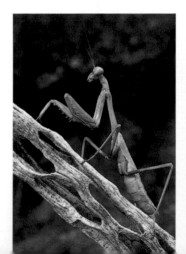

the fruit made by the bats, and the moths in turn become food for desert pallid bats. But the great orgy isn't over yet. As ethnobiologist Gary Paul Nabhan describes, the fruits begin to ferment the next morning, and fruit flies and bees come to imbibe at these ephemeral pools. "They become drunk, fall in, and drown. Doves and hummingbirds get in on the dregs. A multitude of insects swarms in as the day proceeds, working to finish off the mild wine before mid-morning. . . ."

Almost every part of the giant saguaro sees use by some desert creature. Long-nosed bats and white-winged doves sip nectar from the creamy white flowers. Foxes and coyotes eat the red fruit. Ants shuttle away the tiny black seeds once the fruit has fallen to the ground. Gila woodpeckers and gilded flickers peck nest holes into the stems. Inside the saguaro, a thick callus grows around those holes, forming a hollow "boot" expropriated by many other birds once the woodpeckers have moved out. Among them is the sparrow-sized elf owl, surely one of the saguaro forest's most engaging creatures. Much larger birds, such as hawks, osprey, and great horned owls, perch in saguaros and construct big bulky nests in the tops of the branches.

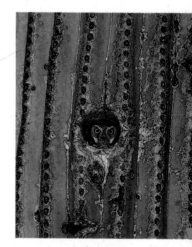

Woodpeckers excavate and use cavities in saguaros. After they vacate the nests, elf owls move in and raise three to five of their own young in these tight quarters. The cavity nests are well insulated against the dramatic temperature fluctuations of the desert.

Insects also live on cacti: cactus beetles feed on the tissue, cactus bugs suck the juices, young hover flies drink fermenting juices, and male wasps called tarantula hawks keep watch for females from the heights of saguaros.

Even wounded and decaying cacti support an intriguing Lilliputian world of organisms. First, a wind- or animal-borne bacteria infects a wound in a cactus. Fruit flies then enter and introduce a yeast. The flies lay their eggs in the rotting tissue, and their larvae feed on byproducts of the fermenting yeast. "Among these materials," writes biologist John Alcock, "are volatiles that attract both scavenging cactophilic flies and human researchers, who follow their noses to the not unpleasant odor of rotting cacti in search of the specialized insect fauna associated with these plants." This is a highly coevolved affair: Each group of cactus—saguaros, senitas, organ pipes, prickly pears, chollas, and others—has a specific type of bacteria and a specific fruit fly. The level of specificity may have developed, Alcock thinks, because a given fruit fly has enzymes that let it digest the toxic chemicals specific to each kind of cactus.

The question of how long-lived cacti finally die has been much debated. The main protagonists are bacteria and freezing temperatures. It is well known that freezing is the greatest enemy of many cacti: they can be damaged if temperatures drop below freezing for more than a few hours, and they are killed if the duration is more than twenty-four hours. Cacti that manage to live in colder climates do so by losing water, growing closer to the ground, and "hardening off" as temperatures drop, sometimes to forty below zero in parts of northern Canada where only *Opuntias* survive. Others, such as the small pincushions and *Pediocactus*, retreat underground entirely in a plant version of hibernation.

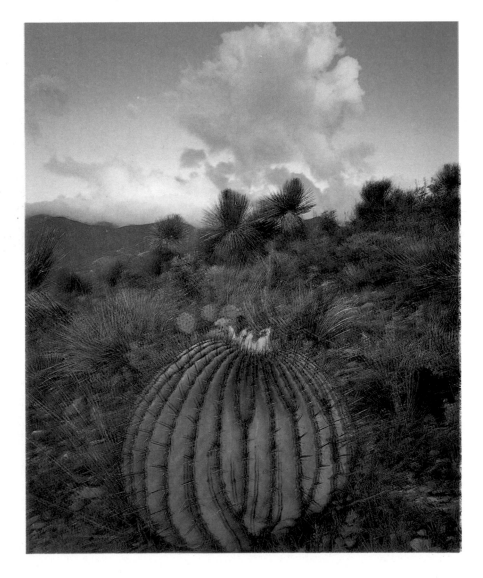

LEFT: Biznaga de dulce (Echinocactus ingens) *with yuccas in the foothills of the Sierra Madre in Nuevo Leon, Mexico. These many-ribbed, rotund barrels can grow up to four feet in diameter. The stems of several kinds of barrel cacti, including* Echinocactus ingens, *are cooked into sweet candy.* OPPOSITE: *The thick-walled, nearly spineless stem of an aged cardon* (Pachycereus pringlei). *These venerable cacti can remain standing for many years, as wounds become infiltrated by bacteria and decay progresses. Freeze and drought also contribute to their demise.*

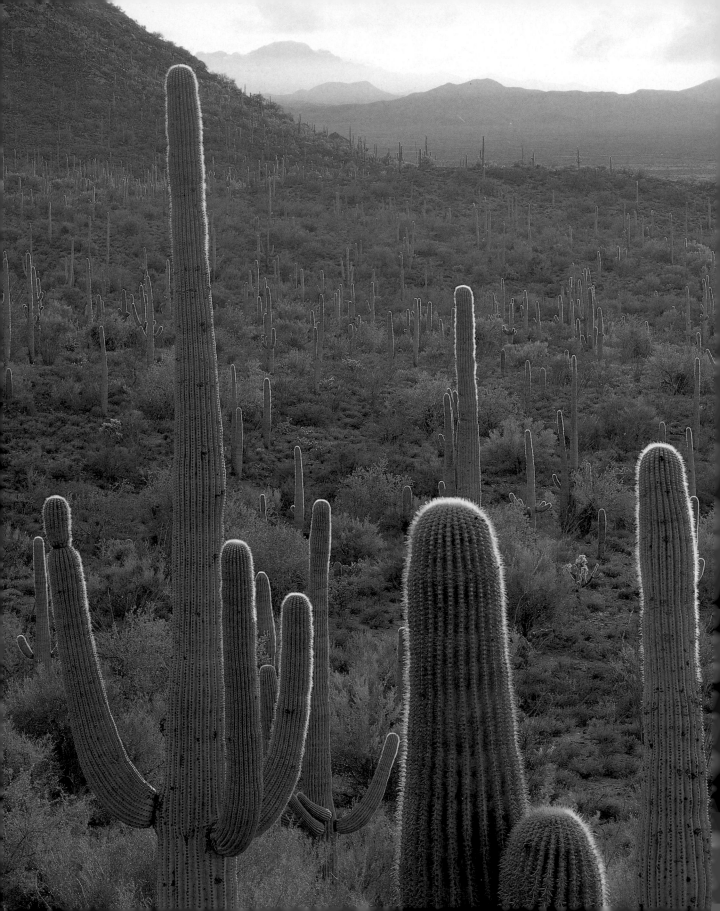

Saguaros are especially sensitive to frost, which is why they are almost exclusively found on south-facing slopes of mountains where they are best protected against winter cold (and where the rocky ground gives up more moisture). Periods of cold temperatures leave clear marks on the stems of saguaros. Where damage has occurred, the stems are cinched in like a belt tightened around a waist.

Saguaros were objects of study when the bacteria-versus-freeze debate raged in the 1940s. Great old patriarchs in then Saguaro National Monument (now national park) on the east side of Tucson, Arizona, were dying from what scientists thought was a new bacterial rot. Drastic measures were taken to keep the "disease" from spreading: arms were chopped off infected plants, and whole saguaros were bulldozed and buried. Other measures such as artificial propagation were undertaken, but in vain. It appeared that the saguaro forest was doomed. Then, studies began to show the dieoff was due instead to long-term climatic fluctuations. Freeze-caused deaths were simply part of a natural evolutionary process. These particular saguaros, at the northern limits of their range, were more susceptible to any stress, and the bacteria invaded those plants already damaged by cold.

Fortunately, a vital, younger saguaro forest exists within the boundaries of a separate part of the park on the west side of Tucson. Amid fantastic forests of saguaros on the slopes of the Tucson Mountains, I can still hear doves calling softly in the cool morning. During the night, I hope, a bat visited a saguaro flower and carried pollen to another flower. Eventually, a nubby green fruit forms and splits open atop the saguaro, displaying bright crimson pulp. A single tiny black seed from that fruit reaches the ground beneath a palo verde tree at just the right moment. A new saguaro seedling sprouts, beginning a long and determined life.

Thinking back to that heady June evening when the night-blooming cereus sent out its fragrant flower, I am reminded that cacti are capable of many miracles. No matter how much we know of their lives and deaths, they will continue to surprise and please us with their extraordinary adaptations.

A healthy, reproducing population of saguaro cacti (Carnegiea gigantea) *graces the* bajadas, *or slopes, of the mountains west of Tucson, Arizona. The loose, bouldery ground of the* bajadas *releases more moisture to the plants than do the heavy clay soils of the valleys, and helps anchor saguaro roots to minimize windthrow. Thus, the finest stands of saguaros always occur on the hillsides.*

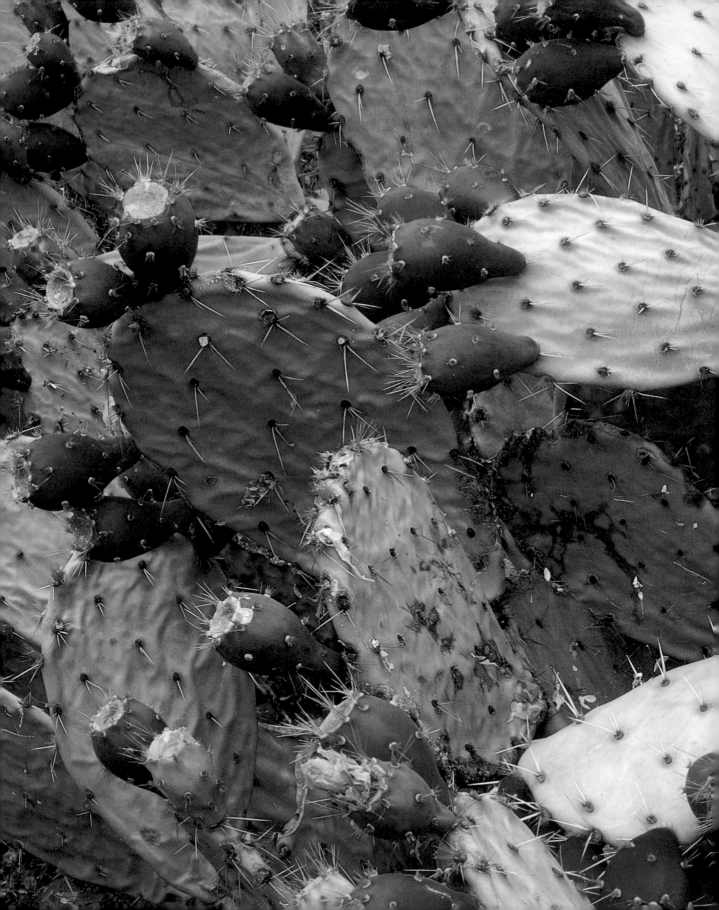

Cactus for Mind and Body

Cactus for Mind and Body

"WHERE CACTI THRIVE, it is doubtful if any man should die of thirst or hunger." So declared Southwest botanist Homer Shantz. Indeed, for at least the last 10,000 years, cacti have sustained both body and mind of those people who live within their range.

All kinds of cacti have served all kinds of functions: food, drink, medicine, and utilitarian items, even religion and ritual. Consider the common prickly pear. Every part of the plant—fruits, seeds, pads, even the sap—has been eaten in some form or another. The pulpy, sweet fruits, known as tunas, cactus pears, or pear apples, have long been consumed by native Americans and are now cultivated and sold in markets around the world.

Most visitors to the Southwest have seen jars of prickly pear jelly on the shelves of specialty stores. The deep purple contents are made from the cooked fruit pulp. Should you wish to make your own batch, a word of warning from the voice of experience: The pulp does not always gel as planned, even with the addition of sugar and store-bought pectin. Though I didn't know at the time of my jelly failure, the thick syrup is sold in Mexico as a sweet taffy or honey. It's also cooked, cooled, and made into cakes called *queso de tuna,* or cactus pear cheese.

The Indian fig, *Opuntia ficus-indica,* is an especially popular prickly pear and has become so widespread that its exact New World origin cannot be determined. Columbus may have taken this species back to Spain, and the well-to-do of Europe soon took to growing it on rooftop gardens. From there, *O. ficus-indica* spread all over the Mediterranean area. This tree-sized plant was also introduced along the coast of California by Spanish missionaries and became known as the "mission cactus" (the mucilage in the plants was used in the adobe bricks for their missions.)

Now, at least 150,000 acres of Indian fig are cultivated in warm areas in Mexico, South America, Europe, Africa, and Asia for the yellow, orange, or red fruit. In Sicily, orchardists made the chance discovery that removing the flowers in early summer stimulated a renewed flowering period and assured an autumn harvest of larger, sweeter fruits.

PRECEDING PAGES: *Prickly pear cactus* (Opuntia phaecantha). INSET: *Claret cup cactus* (Echinocereus coccineus). ABOVE: *Prickly pear* (Opuntia phaecantha). OPPOSITE: *A prickly pear cactus* (Opuntia engelmannii var. discata) *has found a foothold on a sandstone wall in Zion Canyon in southeast Utah. Prickly pear are among the hardiest cacti, often surviving where others cannot.*

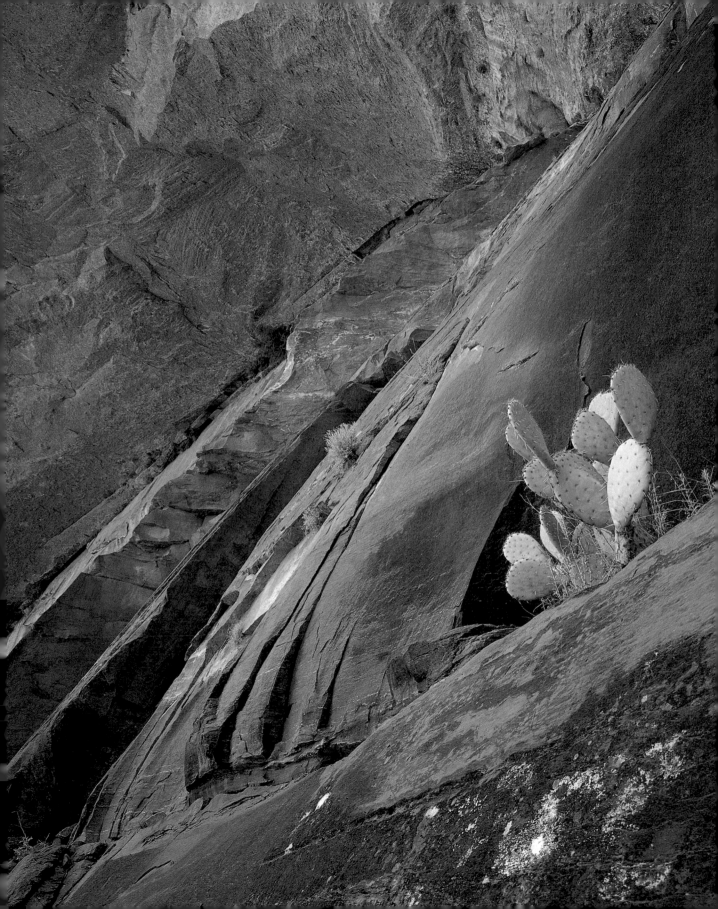

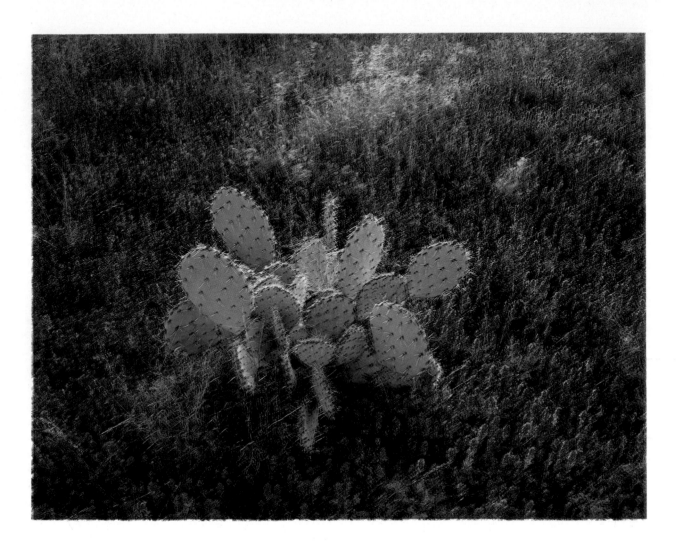

No discussion of *Opuntia ficus-indica* would be complete without recounting the tale of Luther Burbank's grand experiment. The famous plant breeder selected a spineless hybrid of *O. ficus-indica* and actively promoted its use as cattle fodder. In the early 1900s, Burbank's spineless prickly pear plants were introduced to Australia, where they thrived. Unfortunately, their offspring were both spineless and spined. Cattle and sheep turned up their noses at the spiny plants, and the prickly pears began to take over with a vengeance. At one point, *O. ficus-indica* and two other species of prickly pear reportedly were infesting rangeland at an astounding rate of 250 acres an hour!

To halt this spread, a hard-pressed Australian government tried various controls, some of them drastic. They brought in insect pests, applied poisons to the plants, and even killed birds to stop spread of the seeds. Moth larvae that chomped happily on the pads were introduced and finally did the trick. Yet prickly pears are still planted as cattle feed during drought times in some parts of the world, most notably south Texas, northeast Brazil, parts of Mexico, and South Africa.

The flat pads, or stems, of prickly pear are sold under the name *nopales,* or if sliced and diced, *nopalitos.* Tall bundles of the pads are shipped into Mexico City during certain times of the year. For best results, the pads should be harvested when they are young and tender. Once the spines and glochids are removed, this green vegetable is incorporated in many dishes. Sometimes the slices can be found bottled in a marinade. If you like green peppers, you'll like *nopales.*

The columnar cacti of southern Arizona, Sonora, and Baja California are also justly famous for their fruits. *Pitaya dulce* (the organ pipe cactus), **pitaya agria,** cardon, and saguaro all produce large fruits whose traditional harvest has been integral to the lives of the people who share the desert with them. The range of the cardon and the original homeland of the Seri Indians along the Gulf of California was one and the same. To the Seri, a cardon with young fruit was said to be pregnant, and the tiny new fruit was considered the offspring of the cactus.

Fruits of columnar cacti ripen at the end of the dry season, usually in June, when turkey vultures fly in the hot

OPPOSITE: *A prickly pear cactus* (Opuntia phaecantha) *grows among owl clover in full spring glory in the Santa Catalina Mountains north of Tucson, Arizona.* RIGHT: *A coral vine climbs along the stem of a* pitaya agria *cactus* (Stenocereus gummosus) *in Baja California.* Pitaya agria *bears a slightly sour fruit enjoyed by native people in Mexico.*

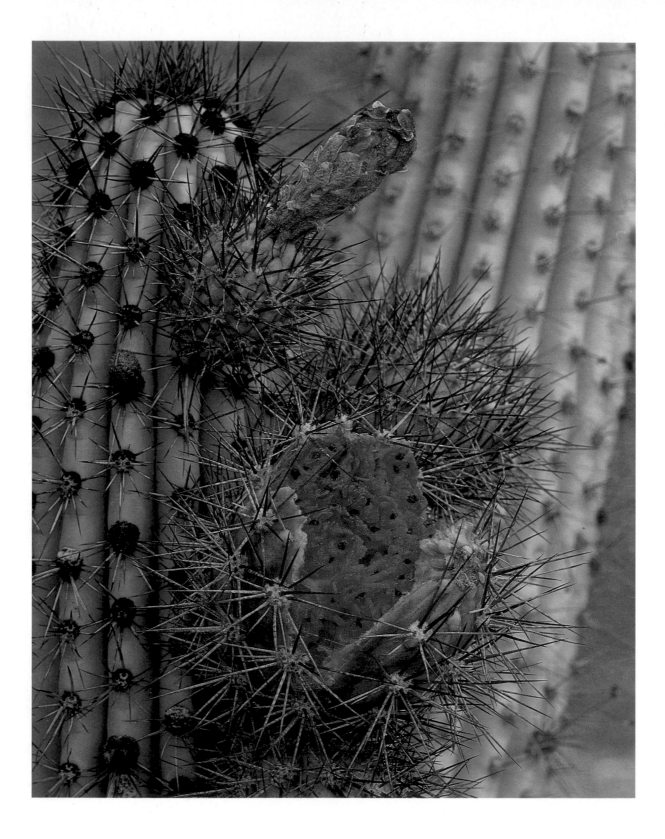

sky. The fruits burst open to reveal their crimson pulp, advertising their availability to people and animals alike. To the Seri, June is the month of the "moon of the ripe fruit." Someone would bring the first fruit buds into camp to let everyone know the harvest was near. Young children, however, were not allowed to touch the buds, lest their lives be shortened.

Everyone in the family joined in at harvest time, but women usually did the actual gathering. They went out in the morning when the fruit was freshest, knocking the morsels from the towering cacti with long poles. They carried the fruit back to camp in baskets balanced solidly on their heads. Some fruit was eaten, some was dried and stored, and some was fermented into wine.

The fruit pulp is high in sugar, and the numerous tiny black seeds are packed with protein and oil. The Seri took advantage of the nutritional value of the bountiful seeds in an unusual way. After eating the cactus fruit, the people defecated on rocks, let the fecal material dry in the sun, and then separated the seeds, cleaned them, and cooked them; it was called the "second harvest."

The same custom was observed among the Indians of Baja California in the mid 1700s with organ pipe cactus, the *pitaya dulce* or sweet pitaya. Father Jakob Baegert asked permission of his "more modest readers" to relate something "completely awful and disgusting." He went on to describe the process as delicately as he could:

> . . . the pitahayas [sic] contain a large amount of small seeds like grains of powder, and the stomach, I do not know why, cannot digest them but releases them intact. In order to use these grains during the pitahaya's time of fruiting, they collect the excrement and separate the seeds, roast them, grind them and eat them while making jokes; the Spanish call this the second harvest.

Although the idea of the second harvest may offend some people's sensibilities, to native desert dwellers it was an act born of necessity that showed precise adaptation to their arid land. In fact, while the fruits and seeds of the cacti were available, people could relax and celebrate, knowing their stomachs would be full for a little while.

For the O'odham (the Pima and Papago) of the Sonoran Desert, the old year ends with the cactus fruit harvest, followed by the new year and the arrival of the summer monsoons. Each year, to "bring down the rain," the O'odham make wine from fermented saguaro juice and drink the mild wine in a ceremony.

Birds have opened the ripe fruit of an organ pipe cactus (Stenocereus thurberi), known in Mexico as pitaya dulce. Bats and moths also come to feed on the sweet fruit and flower nectar. The lives of native desert people have been intricately entwined with the organ pipe cactus too. They harvest the fruit, make wine from it, then hold a ceremony in which masked dancers drink the wine to bring rain to their desert home.

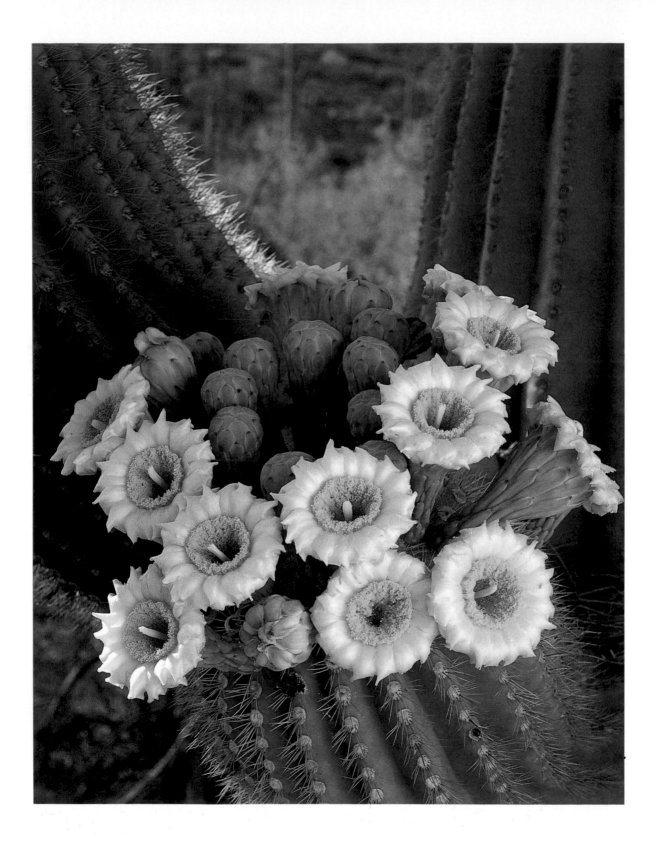

Each June a few desert gatherers return to temporary outdoor camps where they spend a month or so harvesting the fruit with saguaro rib poles. The fruit is sliced open, soaked in water, and the seeds strained out. The sweet juice is cooked into a syrup, which families donate to make the wine for the *nawait* ritual. The people then assemble for the serious purpose of drinking the wine and singing the old songs to bring the rain. Without this ritual of purging and purification, of calling down the clouds and the rain, they believe their crops will not grow.

Fermented saguaro juice may also have been used by the prehistoric Hohokam people as a weak acid with which they etched beautiful designs on shell. Cholla has been used since prehistoric times as well. The pollen of cholla has been found at sites all over the Southwest, from pueblos in northern New Mexico to Hohokam villages near present-day Phoenix, Arizona. Cholla doesn't grow near some of these sites today, leading ethnobotanists to speculate the cactus may have been brought in and deliberately cultivated as a backyard food crop. Because chollas produce buds and flowers reliably each year, they are a sure source of food not easily depleted.

As late as the 1990s, Pima Indians and their Papago neighbors were still going to the foothills to gather the young, unopened flower buds of cholla. With wooden tongs called *vah-o*, made from twisted mesquite or saguaro ribs, they collect a couple of bushels of buds in a few hours. Back at the village, the roasting pit is prepared.

A pit is dug into the ground, into which an elderly man carefully places rocks. A hot mesquite fire is started in the pit and burned down to coals. Stems of seepweed, a clammy shrub in the goosefoot family, are laid over the rocks to form a sort of basket. The cholla buds are then piled on, and finally another layer of seepweed is placed on top. The seepweed (whose name in Pima means "black salt") adds flavor and prevents scorching. The buds are cooked overnight, then removed from the pit and dried in the sun. They can be stored indefinitely, then ground into meal or rehydrated and boiled as a green vegetable. Cholla buds taste much like Brussels sprouts with the texture of artichoke hearts. They are rich in calcium: a four-ounce serving contains more calcium than an eight-ounce glass of milk.

A notable substance supplied indirectly by cacti became a major item of international intrigue and trade during the eighteenth century. It is a dye culled

OPPOSITE: *When the generous blossoms crown the tips of saguaro branches, the old year ends and a new year begins for native people of the Sonoran Desert. In four weeks, by early July, the Tohono O'odham will harvest the fruits both for food and, as with the organ pipe cactus, for a ceremonial wine.* PAGE 64: *Saguaro* (Carnegiea gigantea), *teddy bear cholla* (Opuntia bigelovii), *and brittlebush in bloom during spring in southern Arizona.* PAGE 65: *Brown-flowered cholla cactus* (Opuntia alcahes) *on Isla Espiritu Santo in the Sea of Cortez, Mexico.*

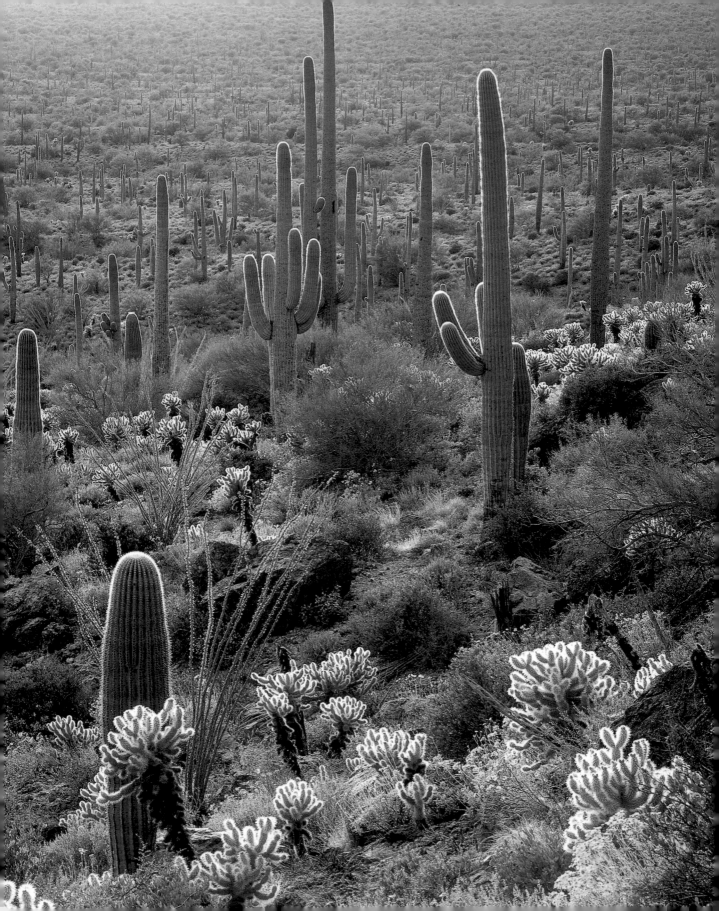

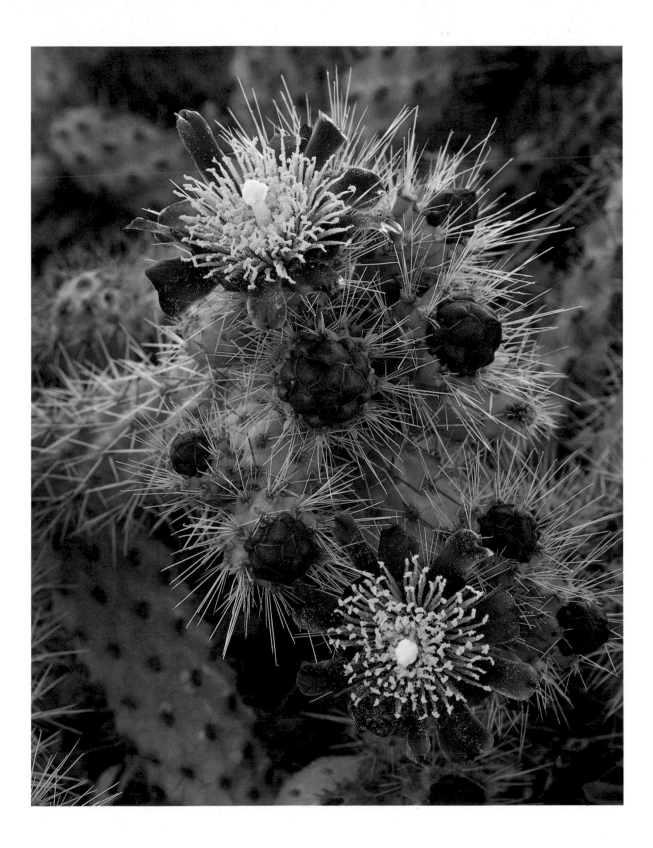

from a tiny insect called cochineal, also known as Spanish Red, or simply "the bug that changed history."

This scale insect, related to mealybugs, lives on the pads of prickly pear and has been known among residents of Mexico for millennia. Upon arriving in New Spain, the Spaniards immediately noticed the incredibly rich red of the robes of the Aztec emperors. They sent some dye back to Europe and people immediately wanted more.

Previously, Europeans and the British had been obtaining red dye from plants such as madder, brazilwood, and a pest of oak trees known as kermes. But what they saw from Mexico was far more dazzling. When a mordant, or setting agent, of tin or alum was used with cochineal, lovely crimsons, pinks, and scarlets resulted. So eye-catching was the scarlet that Catholic cardinals and the British military (hence the "redcoats") soon coveted cochineal to color their garments.

Turkey vultures perch on cardons (Pachycereus pringlei) *on Isla Cholludo in the Sea of Cortez. Historically, the Seri Indians of the region, who call themselves* Comcáac, *the People, used the cardon cactus as a source of food, medicine, tools, and spiritual strength.*

Cochineal farms flourished in Mexico, and the dye became one of Mexico's most important exports. Because the dried insects resemble grains of wheat, people in Europe thought the dye came from a cereal or perhaps a berry. To protect the lucrative industry, Spanish exporters tried to keep the insect source a secret, tightly controlling access to the farms. Eventually, though, the true origin of cochineal dye was discovered: someone may have smuggled out some live cactus pads with insects attached; or, as another story goes, the Dutch scientist Anton van Leeuwenhoek peered into his microscope and saw it was an insect. In the mid-1800s cochineal production reached a peak, but near the end of the century the introduction of synthetic dyes crushed the cochineal dye industry.

The body of the female cochineal insect (*Dactylopius*) yields the dye. She attaches her mouthparts to the pads of prickly pear, surrounds herself with a fuzzy white covering, and feeds on the pads. If you squeeze that cottony mass, you can easily see the deep purplish liquid that accounts for the startling color of the dye. It takes about 70,000 adult females to get a pound of dried material. Today Peru is a leading supplier of cochineal, and most of the harvesting is done by hand. Besides the carmine dye, cochineal is also used for medical tracers, cosmetics, artists' paint, and red food coloring.

Dye is only one item on a lengthy list of utilitarian products obtained from cacti. People have used the ribs of saguaros and cardons for rafts, fences, and beams in their houses. Barrel cacti are hollowed out and made into containers and

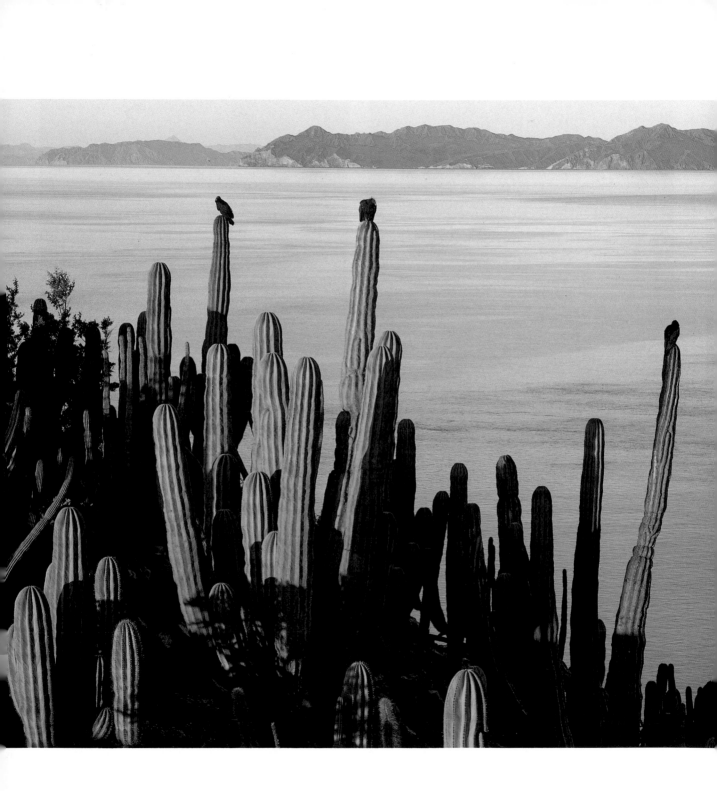

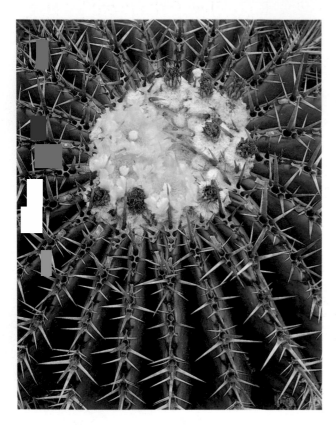
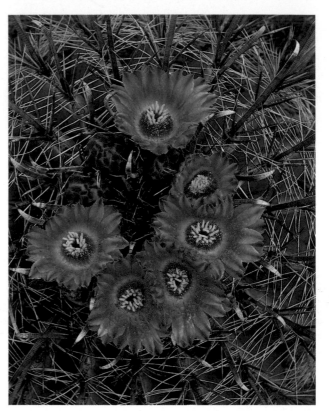

cooking pots; their flesh is cooked into candy; and their spines have served as awls, needles, fishhooks, and even Victrola needles! The barrel, of course, is well known as a source of survival water, but some barrels contain minerals that bring on severe intestinal distress. Should you become lost in the desert, observe the direction a barrel cactus faces. Nineteenth-century explorers called them "compass plants" because of their tendency to lean south toward the equator.

Need a hairbrush in a hurry? In southern Baja California, the stout-spined fruit of a cardon called *Pachycereus pecten-aboriginum* served handily for this use. The Seri mixed dried organ pipe cactus with oils from the fat of a sea mammal, then cooked it into a black tar for caulking boats. They also fashioned an ingenious wheeled toy from the woody stem of senita cactus.

Early Mormon settlers in the Southwest learned the hard way what Navajos of that country had known for some time—cacti also possess healing properties. In 1881, a young Navajo medicine man named Baililly came upon settler Jody Lyman and his companions. Lyman's femur had been shattered when he was shot by horse thieves in an ambush at Hall's Crossing in southeast Utah. His friends

The cacti on these pages are all known as barrel cacti. ABOVE LEFT: *A large* Echinocactus ingens *in bloom.* ABOVE RIGHT: Ferocactus wislizeni *in Organ Pipe Cactus National Monument in southern Arizona.* OPPOSITE TOP: *Mexican fire barrel cactus (*Ferocactus pilosus*) with lechuguilla in Sierra Madre foothills, Nuevo Leon, Mexico.* OPPOSITE BOTTOM: *California barrel (*Ferocactus acanthodes*) in Anza-Borrego State Park, California.*

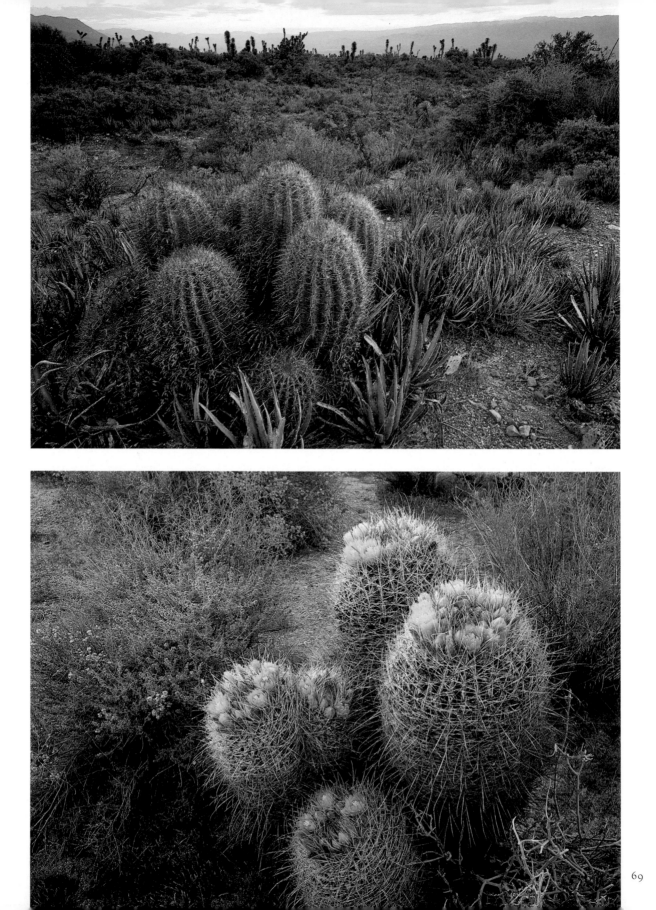

were trying to get him back to the tiny town of Bluff to receive the only medical help then available in that remote country: the folk cures of the Mormon women who were known as "doctor ladies."

Lyman was near death when Baililly found him out in the desert. For two days, Lyman's four companions had not been able to move him because his pain was too great. Seeing the situation, Baililly immediately directed the men to gather the stems of prickly pear and burn off the spines. The pads were pounded into a poultice that was applied to Lyman's leg. Although the cactus dressing did not mend the broken bone or ease the pain, it did stop the infection and helped heal the wound. Finally a wagon arrived from Bluff and took Lyman home. He was crippled for life, but the prickly pear poultice treatment was quickly adopted by the Mormon "doctor ladies."

Native people in Mexico willingly shared cactus fruits with European sailors who began reaching their shores in the sixteenth century. The fruit, rich in vitamin C, cured scurvy that was the plague of seamen. The tuber of the night-blooming cereus was boiled and taken in a concoction for diabetes. The saguaro, the Pima believed, would "keep the stomach warm" and make milk flow after childbirth. The Seri removed the spines from a saguaro or cardon stem, heated a slab of the plant on coals, and placed it on aching joints. The Hopi chewed cholla root to relieve diarrhea. Earache was treated with eardrops made from the liquid of a crushed mammillaria. And the senita cactus is still one of the most important medicinal plants in Mexico, some claiming it possesses cancer-curing properties.

Beyond practical uses, cacti have fulfilled the needs of spirit and soul as well. The Seri say the senita was one of the first plants ever formed, and its powerful spirit hovers above the plant like a fog. With great respect, they ask the spirit to help them, to place a curse on an enemy, or to bring good luck. Likewise, they placed clam shells in the bark of a cardon to bring luck. Even in death, cacti served a purpose. A miscarried or stillborn child was wrapped in cloth, put in a box, and buried on a brush platform in the limbs of a cardon.

Since ancient times Peruvian *curanderos,* or healers, put trust in a trichocereus called the San Pedro cactus. *Curanderos* boiled slices of San Pedro cactus in water and drank the liquid. Then they sang songs, asking the cactus to help them see the patient's illness and to let them know what herbs to use in treatment. The Catholic Church opposed use of the San Pedro cactus because of its hallucinogenic effects.

This beavertail cactus (Opuntia basilaris), normally spineless, has probably hybridized with a spined prickly pear cactus. Beavertail cacti and related hybrids grow in sandy areas throughout Zion National Park in southeast Utah, where this specimen was found. They creep across the ground, each pad taking root where it touches the soil. Unlike most prickly pears, the fruits of beavertail are often dry and unappetizing.

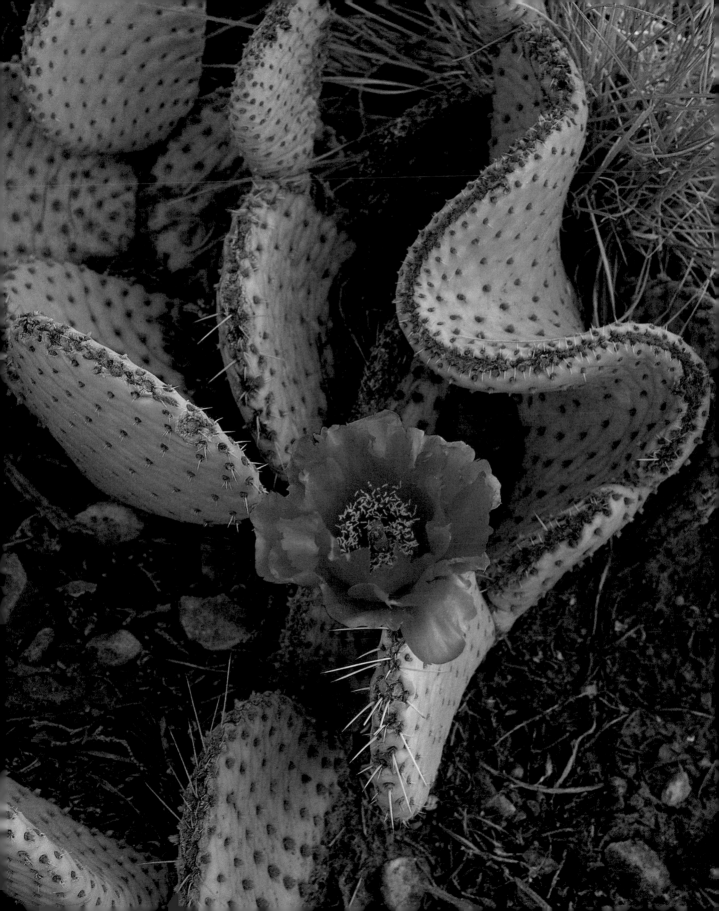

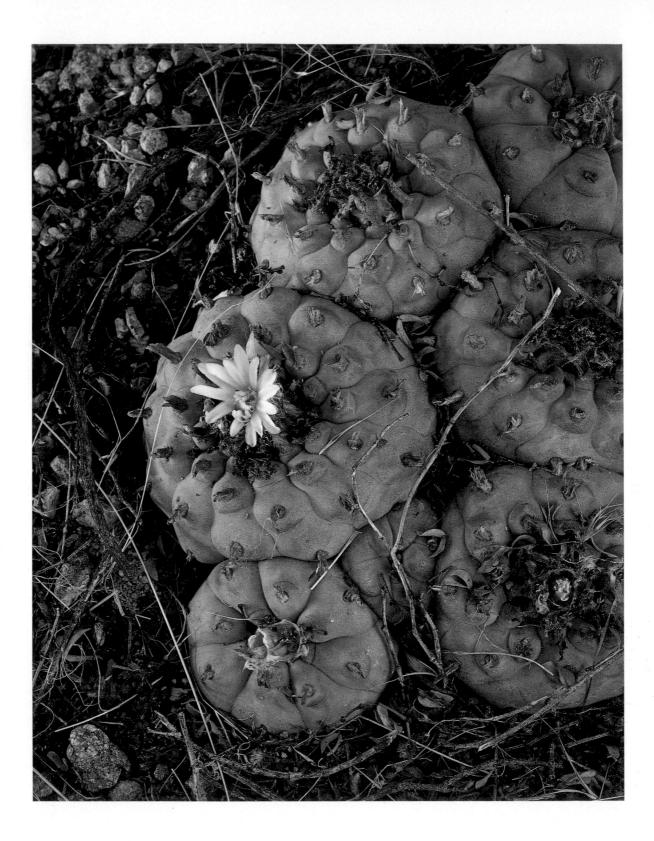

Perhaps the most famous cactus imbued with spiritual qualities is peyote. *Lophophora williamsii* is the species most commonly known as peyote, a small blue-green cactus that looks like a mushroom. It also goes by other common names, including dumpling cactus, devil's root, mescal button, and dry whiskey. In Greek, *Lophophora* means "I bear crests," referring to the wooly tufts on the areoles of the cactus. The areoles of peyote don't bear spines except in the seedling stage.

This unassuming Chihuahuan Desert plant possesses numerous alkaloids, most notably mescaline, that induce hallucinations and supernatural visions. Peyote is reputed to cure witchcraft and disease and has been used in the New World for at least six thousand years. Certain groups in Mexico, including the Tarahumara, Cora, Tepecano, and Huichol, have had long experience with peyote. The Huichol are known as the "peyote tribe," and they conduct intricate annual rituals associated with the gathering of peyote.

In the United States, peyotism has been practiced at least since the late nineteenth century. In the early 1900s, Plains Indians and others founded the Native American Church, a religion centered on the use of peyote. All-night ceremonies are held in which peyote is taken as a sacrament to communicate with God. In a round building such as a tepee or hogan, people sit in a circle around an altar. A "roadman" conducts the ceremony, which involves singing, praying, and drumming. In the morning, when the ceremony is done, a breakfast of corn, meat, fruit, and water is served to all the worshipers.

Despite peyote's strict religious association with the Native American Church, it has been viewed in some quarters as a dangerous, addictive drug. Anti-peyote laws have been enacted at both tribal and state levels and, to complicate matters, peyote became known among Anglos in the 1960s as a recreational hallucinogenic drug. Finally in 1971, federal law made it illegal to use peyote except for Native American Church ceremonies. Still, church members have had to go to court, including the United States Supreme Court, several times to try to assure their First Amendment religious freedom rights.

No wonder then that cacti have been held in such high esteem and that people have gone to such great lengths to protect their rights. Cacti have been nothing less than a cornucopia, a mainstay of life, for longer than anyone really knows. Those words of the early botanist ring true. No one living in the land of cactus must ever want for food, drink, or spiritual sustenance.

Peyote cactus (Lophophora williamsii) *has been known since ancient times for its ability to induce powerful visions. The Huichol Indians believe the deer-god left peyote plants in his tracks when he first came into the land where peyote grows. At the time of the Spanish Conquest in Mexico, priests condemned this "satanic enticement," and the Catholic Church banned peyotl. Legal religious use of peyote among native Americans in the United States continues to this day.*

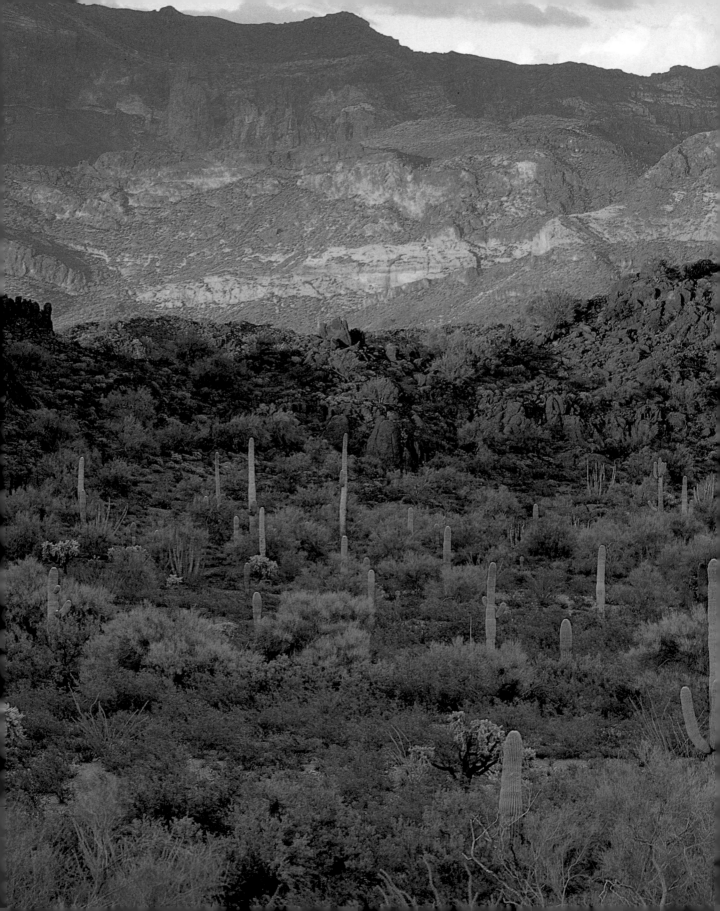

The Cactus Chronicles

The Cactus Chronicles

IN MEXICO, legend tells of a priest's dream of a cactus growing from a rock and turning into a tree in which a caracara perched. The place of this prophecy inspired the Aztecs to settle their capital of Tenochtitlán in 1325. Tenochtitlán is now Mexico City, and the Mexican flag still proudly bears the symbol of a caracara perched atop an *Opuntia* cactus.

Certainly native people of Mexico and the rest of the Americas have known of cacti since prehistoric times. Then, in 1492, Columbus sent back a cactus, possibly one known by the common name of Turk's head, to Queen Isabella. As Spanish conquistadors and missionaries entered the New World and sent back word of cacti, these strange and wonderful plants soon became known to the European world. In the sixteenth century, several books, including Gerard's classic *Herball* published in 1597, carried the names of a few cacti.

Throughout the 1600s and 1700s, cacti made their way back to the Old World in increasing numbers. Live specimens survived in orangeries, hothouses where citrus trees were cultivated. Growing interest in the exotic cacti was accompanied by a host of bewildering names for various species. Finally, in his *Species Plantarum* published in 1753, the great Swedish botanist Carolus Linnaeus classified twenty-two species of cacti under one genus which he called *Cactus*. Soon thereafter his classification was altered, and a nearly constant procession of nomenclatural changes has continued ever since.

Among the cacti Linnaeus described was an *Opuntia* from Virginia, then the only cactus known to science from the United States. Cacti had been reported along the coast of southern California by naturalist Archibald Menzies in 1793, but not until the early 1800s were the first collections made by naturalist Thomas Nuttall.

Born in Yorkshire in 1786, and a printer by trade, Nuttall learned botany among the slopes of his native land. His enthusiasm for natural history drew him to Philadelphia in 1808, where he soon came under the influence of botanist Benjamin Smith Barton and famed plant·man William Bartram.

PRECEDING PAGES: *The Ajo Mountains with saguaro cacti* (Carnegiea gigantea). INSET: *Stem of organ pipe cactus* (Stenocereus thurberi) *with nightshade.* ABOVE: *Texas prickly pear cactus* (Opuntia engelmannii var. texana) *and mallow in Big Bend National Park, Texas.* OPPOSITE: *Saguaro cactus in bloom, Saguaro National Park, Arizona.*

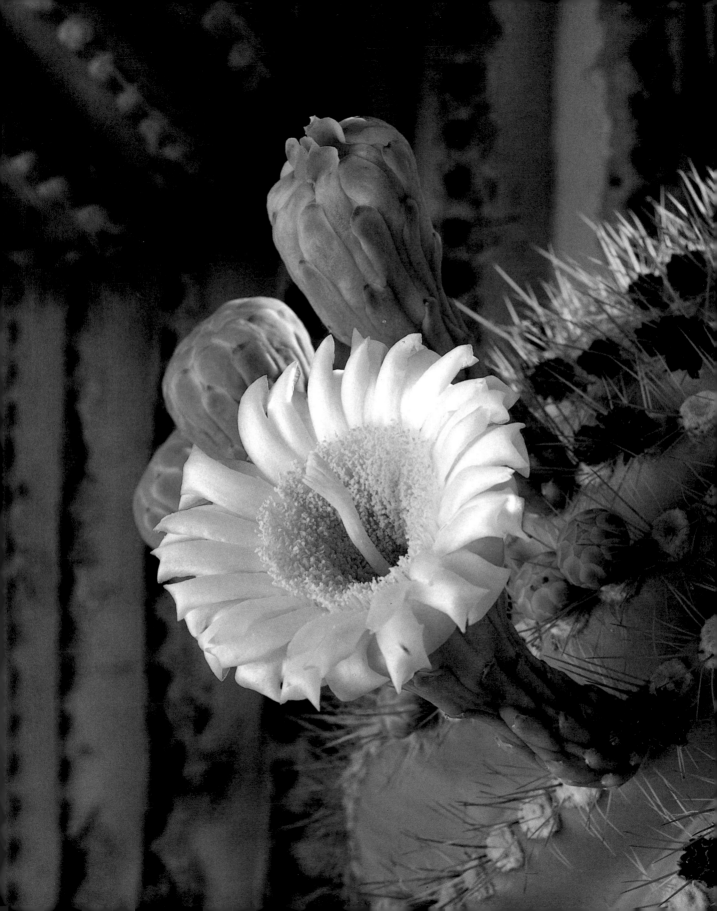

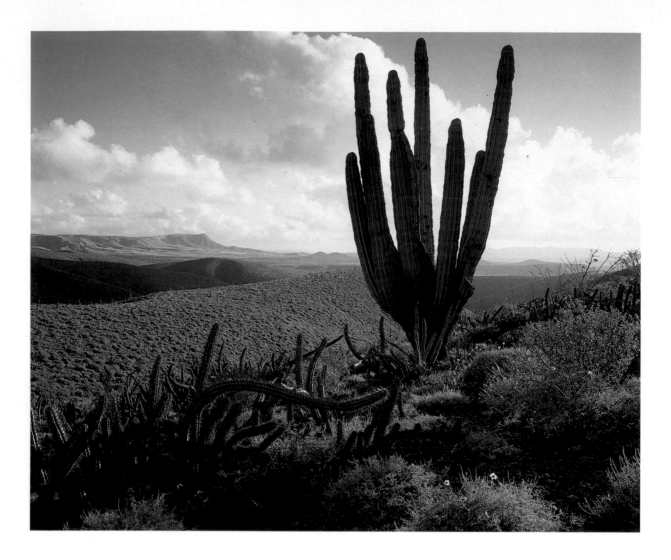

Still working six days a week as a printer, Nuttall devoted every spare second to his first love, plants. After only two short years, in April of 1810, an eager but naive Nuttall set out on a momentous two-year collecting trip up the Missouri River into the immense wilderness of the Great Plains. His contract with Benjamin Barton specified a salary of eight dollars a month, all expenses paid.

Traveling much of the way on foot and by boat and suffering from attacks of ague, Nuttall proceeded with great difficulty across the Great Lakes, down the Mississippi River to Saint Louis, then up the Missouri in the company of Astorian fur hunters. By all reports, he was singularly devoted to his botanical pur-

OPPOSITE: *Cardon (Pachy-*
cereus pringlei) and low-
growing pitaya agria *(Steno-*
cereus gummosus) on Mesa
la Sepultura in northern Baja
California. So abundant are
cardons, the peninsula was
once called Isla de Cardon.
Botanists began to explore
Baja California in the mid-
nineteenth century, and they
could not fail to notice this
giant, awe-inspiring cactus.
PAGE 80: *In the Catavina*
Boulder Field in northern Baja
California, cardon cacti
(Pachycereus pringlei) tower
over elephant trees and yellow-
flowering brittlebush. The
tapering spires of the unusual
boojum tree are seen to the left.
PAGE 81: *A barrel cactus*
(Ferocactus gracilis) in morn-
ing fog in the same location.
Botanists have long noted that
Baja California is home to
many endemic cacti found
nowhere else in the world.
This barrel cactus is one.

suits, blithely oblivious to ordinary concerns such as food, time, distance, or personal comfort.

Nuttall spent the summer of 1811 near the Mandan Indian villages in what is now North Dakota. During that time, he collected four species of cacti—two *Opuntias* and two *Coryphanthas*—the only four species that exist in North Dakota. Nuttall continued his botanical explorations, making significant cactus collections around San Diego, California, in 1836 as well.

The first collections of cacti in Baja California were made in 1839 by Richard Brinsley Hinds, surgeon on the H. M. S. *Sulphur.* This wild peninsula is known for varied and unusual members of the cactus family, such as the cardon and the treacherous creeping devil. Hinds said he "studiously" sought cacti and collected so many that "the afterpart of the vessel . . . presented a small forest of them . . . but they one by one pined and died during the subsequent voyage." Despite the losses, it proved a profitable undertaking. Seventy-eight new species, nearly three-fourths of the cacti now known in Baja California, were named from Hinds's collections.

The years from 1845 to 1883 stand as the great age of discovery of cactus species in the United States. Much of the work coincided with the monumental government and railroad surveys that essentially completed the opening of the American West. What these explorers saw as they ventured into the arid regions was a completely alien, and immensely exciting, plant world.

Frequently traveling with the surveyors were physician-naturalists. These dedicated souls, and other collectors supported by eastern patrons, lugged heavy plant presses through all kinds of weather, over all kinds of terrain, and by all means of transportation. Some took the risk of entering Mexico during time of war. After an arduous day of travel, a plant collector worked by fire or lantern light, carefully arranging and cataloging specimens in hopes they would remain intact for the weeks or months before they could be shipped back to botanists in the East or Midwest. Because of their succulent, moist nature, cacti presented a special challenge because specimens needed to be *dry* to last.

During this period, the name of George Engelmann was omnipresent in the cactus world. German-born and transplanted to Saint Louis, Dr. Engelmann ran a busy obstetrics practice in that city, devoting as much time as he could to identifying the many cactus collections sent back to him from the hinterlands.

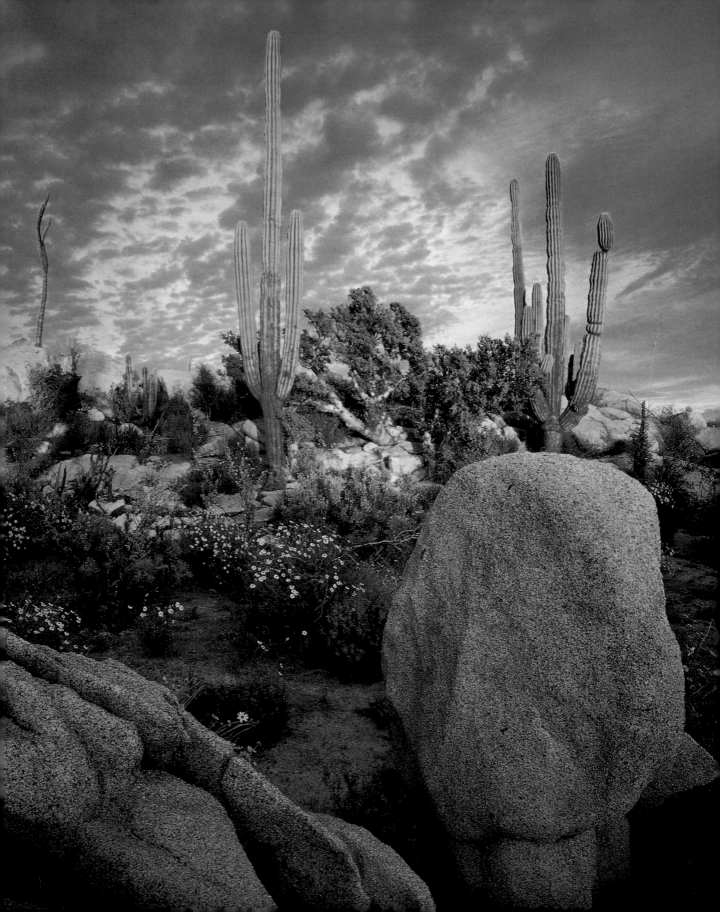

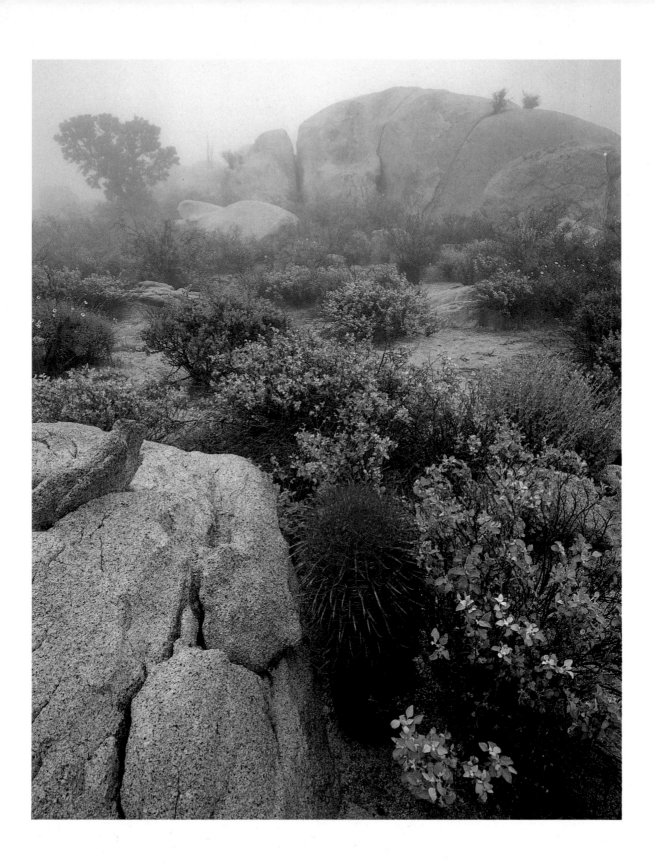

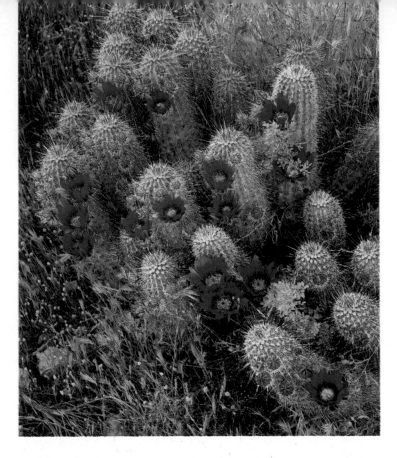

Engelmann adopted the cactus family. Two other giants in the American botanical world, Asa Gray and John Torrey, so trusted Engelmann's judgment that they sent all the cacti on to him for identification. In the mind of cactus expert Lyman Benson, Engelmann was simply "the most outstanding student of cacti of all time." The abbreviation "Engelm." appears often with the scientific names of cacti, indicating Engelmann as the authority for the name. His name is also present in several common names, including Engelmann's prickly pear and Engelmann's hedgehog.

A German-born Texas farmer named Ferdinand Lindheimer began his forty-three-year botanical career at the behest of his friend George Engelmann. Lindheimer was assured he could make a name for himself collecting rare plants in Texas. He proceeded to work along the coast of Matagorda Bay, into the High Plains, and in the Rio Grande Valley, and did gain a small measure of fame with a prickly pear, *Opuntia lindheimeri*, named in his honor. A variety of this species is known commonly as cow's tongue, for the long green pads that do resemble that part of bovine anatomy.

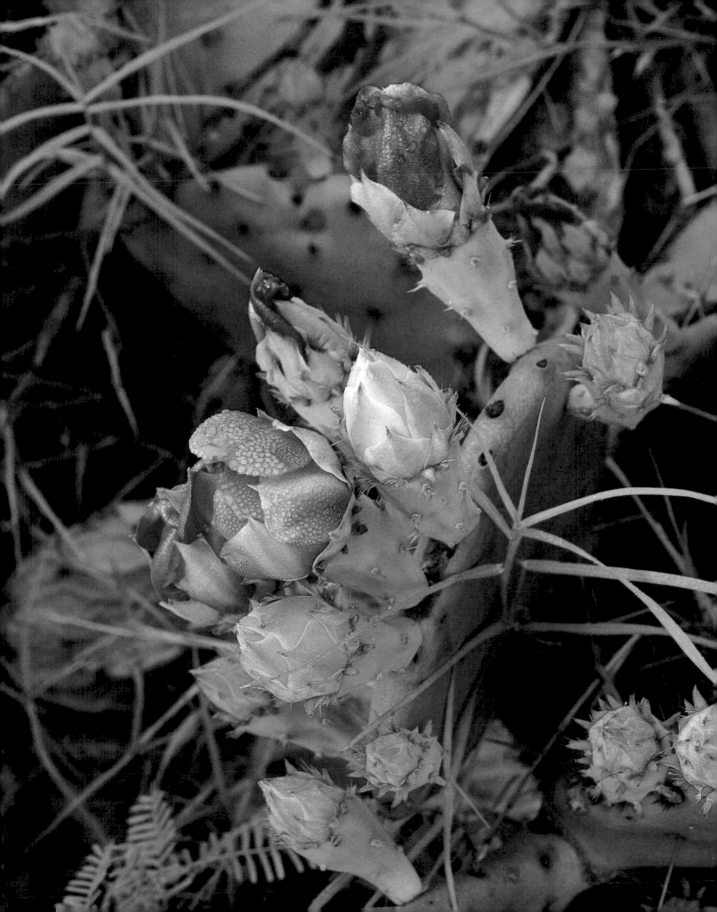

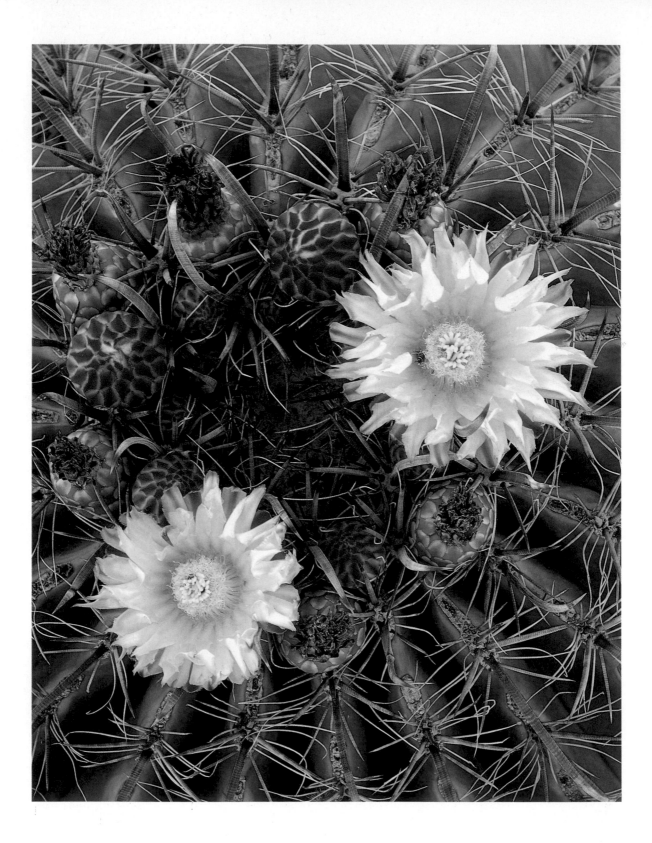

Frederick Wislizenus, who had practiced medicine with Engelmann for six years, set out on an expedition in 1846–47 down the Rio Grande into Mexico. Along the tortuous Jornada del Muerto, a trail that ran beside the Rio Grande in southwest New Mexico, Wislizenus "met on the road with the largest cactus of the kind that I have ever seen. It was an oval Echino cactus, with enormous fishhook-like prickles, measuring in height four feet." He gathered the yellow flowers, seed, and some ribs, but regretted not collecting the entire "exquisite specimen" for Engelmann. Wislizenus did send enough so the good doctor could name the new, undescribed species *Echinocactus wislizeni,* a magnificent barrel cactus common in the Southwest and now known as *Ferocactus wislizeni.*

After ten months in Mexico, Wislizenus completed his extensive journey—2,200 miles by land and 3,100 by water—returning with significant collections. All were examined, naturally, by Engelmann who contributed the "Botanical Appendix" to Wislizenus's report.

During his travels, Wislizenus struck up a friendship with a Santa Fe trader, Josiah Gregg. Born in Tennessee in 1801, Gregg had been bedridden with consumption until a doctor prescribed a trip in a prairie wagon on the Santa Fe Trail. In the decade between 1831 and 1840, Gregg made many traverses over the trail. He published his classic *Commerce of the Prairies* in 1844, a book known to all travelers of the day. Gregg's strong interest in natural science led him to strike up a long correspondence with Engelmann, who encouraged Gregg's botanical leanings. From specimens Gregg sent to Engelmann, the doctor in Saint Louis named three species of cacti: a *Mammillaria;* an *Opuntia;* and *Peniocereus greggii,* the night-blooming cereus.

Soon thereafter followed a major military envoy with ten-mule teams and howitzers, veering westward from the Rio Grande toward San Diego. At the helm of the Army of the West in 1846 was Lieutenant William Emory. Beyond the ninety-eighth meridian, Emory commented on the changes in the country, "the transition marked by the occurrence of cacti." Across the plains, he said, "The eye wanders in vain over these immense wastes in search of trees. Not one is to be seen. The principal growth is the buffalo grass, [and] cacti in endless variety, though diminutive." Along the Canadian River Emory again noted cacti "in great abundance and in every variety." In October, after trying the fruit of the prickly pear, he found that "it tasted truly delicious, having the flavor of a lemon with crushed sugar." Later

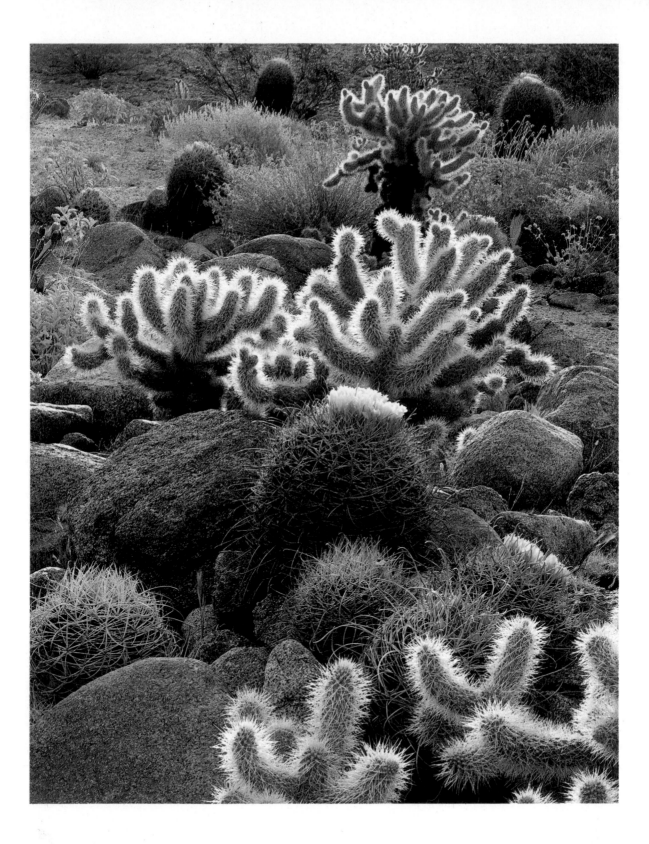

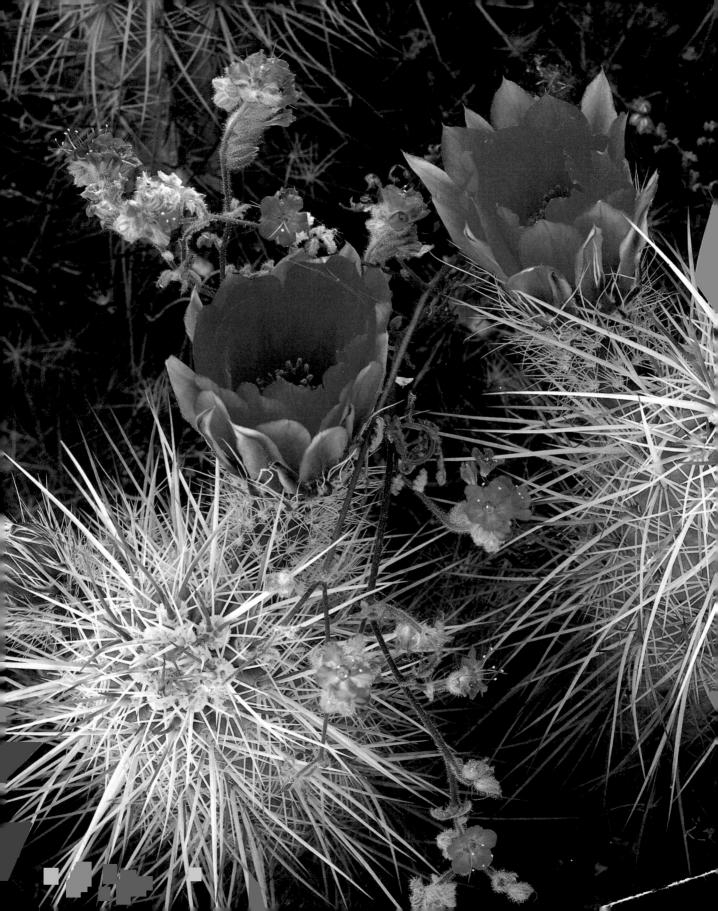

that month, in what is now Arizona, Emory saw "a very great vegetable curiosity." This curiosity was most likely a barrel cactus, for he remarked that "When the traveller is parched with thirst, one of these, split open, will give sufficient liquid to afford relief."

Emory's most famous discovery in this "virgin" botanical country was the saguaro, a cactus whose common name comes to us from the Yaqui Indians. In his report, Emory included a superb engraving of the saguaro he found near the Gila River in central Arizona, a specimen that stood "six feet in circumference, and so high I could not reach half way to the top of it with the point of my sabre. . . ." Emory called the giant cactus *pitaya*, a name applied to several kinds of cacti. In 1848, George Engelmann bestowed the proper botanical name, *Cereus giganteus.* The saguaro was later renamed *Carnegiea gigantea* in honor of Andrew Carnegie, whose institution established the Desert Botanical Laboratory in Tucson, Arizona.

From a distance, the saguaro cactus (Carnegiea gigantea) *William Emory first saw in 1846 may well have appeared similar to this one, growing south of present-day Phoenix, Arizona. The illustration of a saguaro in Emory's report was, according to cactus expert Lyman Benson, the first "a waiting world had of the cactus desert of Arizona."*

The idea of a laboratory to investigate the native plants and animals of the desert was first proposed by Frederick Coville, chief botanist of the United States Department of Agriculture. The Carnegie Institution approved the idea of understanding the processes of plant growth in the desert, so the knowledge could be applied to growing crops in the region. Coville and Daniel T. MacDougal, then with the New York Botanical Garden, suggested that the best site for the laboratory was on a prominence overlooking the dusty frontier town of Tucson.

In 1903, the village of rock buildings set amid the cactus forest of Tumamoc Hill was completed. Botanists William Cannon and Volney Spalding immediately designated plots for plant research. In 1905, D. T. MacDougal left New York and became director of the Desert Laboratory. He approved Cannon's plans and suggested that he also delve into some "fleshy form," such as barrel cactus.

In November 1907, MacDougal and William Hornaday, head of the New York Zoological Garden, set off with a crew of seasoned southwestern explorers on an expedition to the Pinacate region in northern Sonora, Mexico. Their lead vehicle was a four-horsepower White-Water touring car, accompanied by a runabout and two teams of horses and a pair of small mules should the car need assistance. Their outfit consisted of cameras, guns, bedrolls, saddles, food for men and horses, forty gallons of water, and ten pounds of "luncheon chocolate," survival rations no doubt.

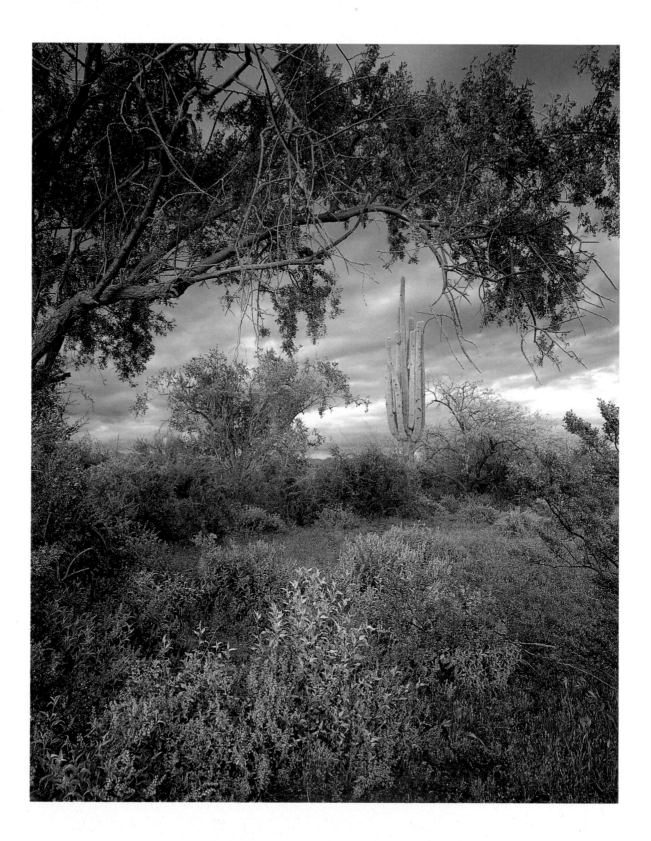

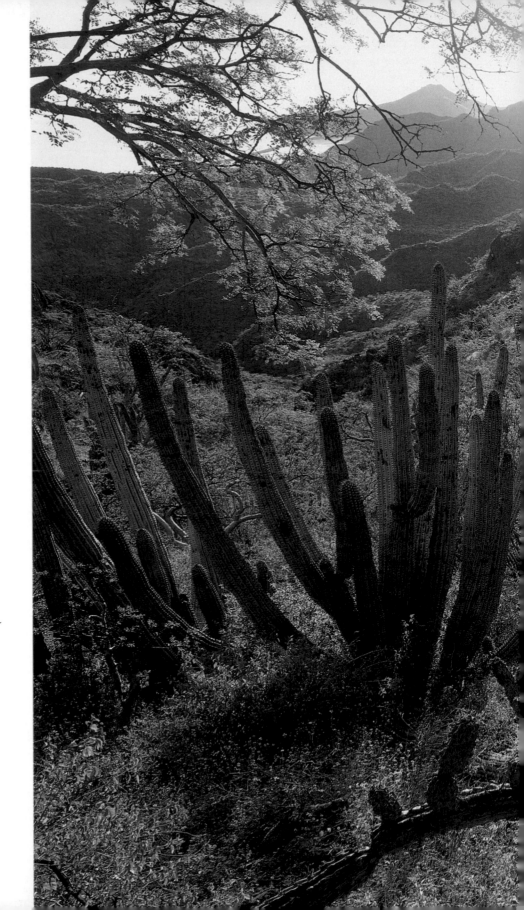

Organ pipe cactus (Steno-
cereus thurberi), pitaya
agria *cactus* (Stenocereus
gummosus), *and* palo
blanco *trees in the Sierra
de la Giganta of southern
Baja California. Jesuit mis-
sionary Miguel del Barco
spent thirty years in the
mid-1700s observing the
natural history here. Barco
noted that winter rains one
year brought "a dressing of
herbs and wildflowers" but
failed to induce the organ
pipe cactus to bear fruit.*

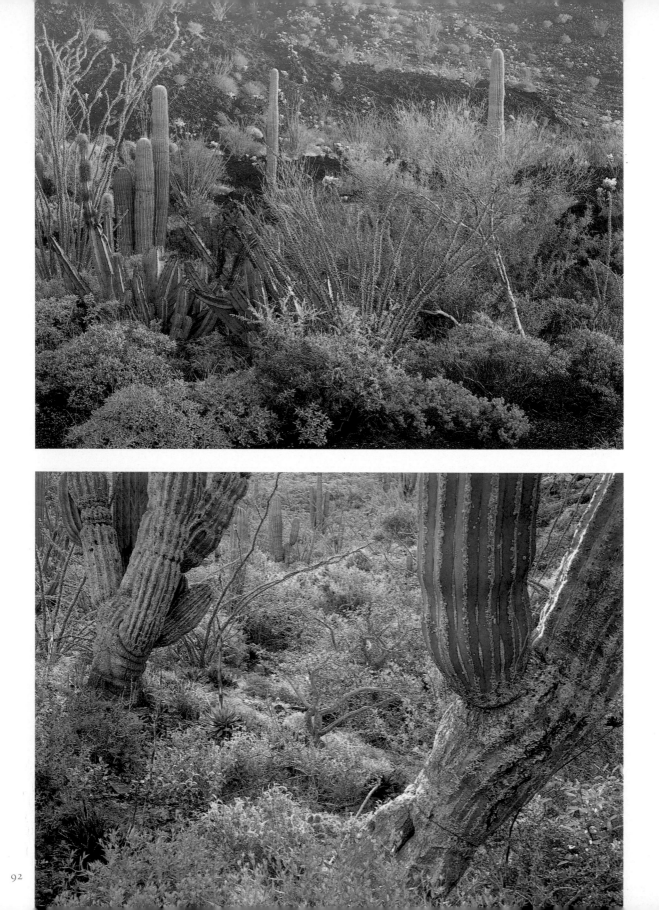

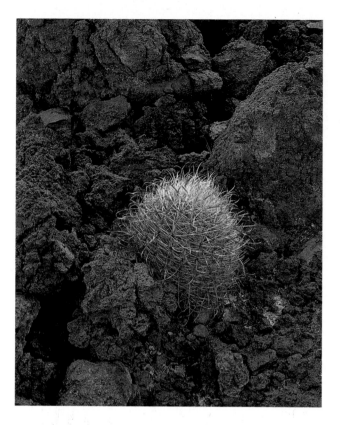

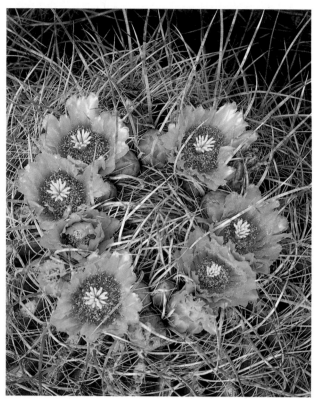

Though the prospect of hunting bighorn sheep piqued Hornaday's interest, he could not ignore the incredible cacti along their route, which made "a great botanical exhibit well worth the labour of the whole trip." So wonderful and varied were they that Hornaday was moved to include a chapter called "The Cactus Display" in his book *Camp-fires on Desert and Lava.* South of Tucson, the saguaros were outstanding. In Hornaday's mind, the saguaro served two important purposes: "to entertain and cheer the desert traveller, and to furnish high places for the nests of woodpeckers." The organ pipe cactus, he wrote, "capriciously clings to the . . . foot of the mountains . . . well placed to be seen of men." The portly, picturesque barrel cactus, the "Traveller's Friend," was "a vegetable to be reckoned with." The book contains a photograph of three trailworn expeditioners cutting off the top of a huge barrel and pounding the pulp to extract water from it. Among other cacti he noted were chollas, including "Bigelow's Accursed Choya," whose worst feature was its spiny "treachery." And at the border town of Sonoyta, MacDougal succeeded in identifying a new species of prickly pear.

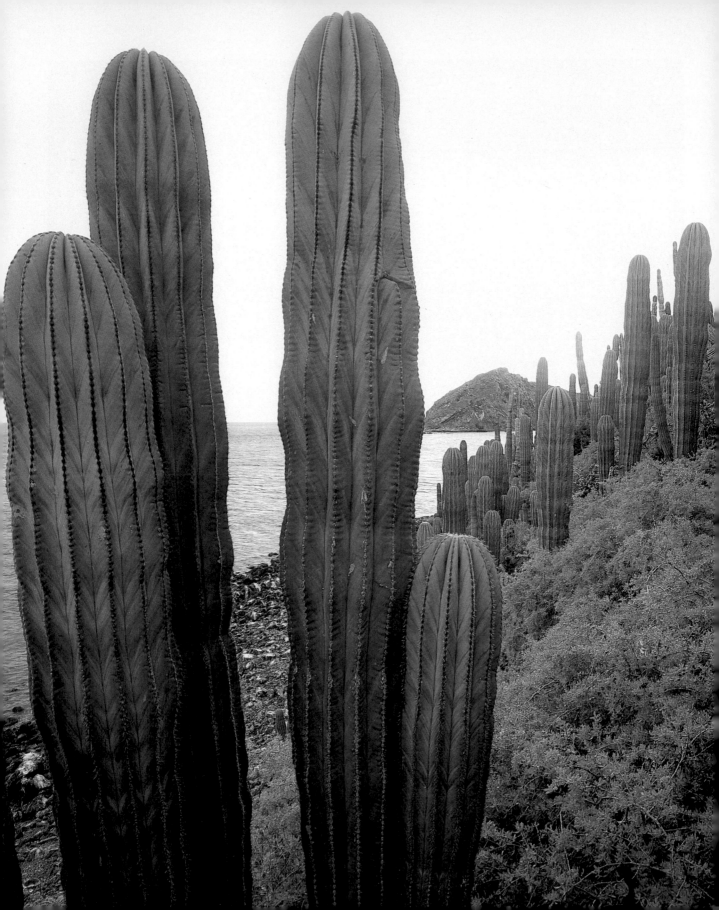

A year after the Pinacate expedition, plant ecologist Forrest Shreve arrived at the Desert Laboratory and became the director in 1928. In landmark publications, Shreve defined the biological boundaries of the four major deserts of North America and described the vegetation of the Sonoran Desert, including the representative members of the cactus family which he studied in detail.

While Shreve focused on the ongoing lives of cacti in their desert environment, back on the East Coast two other botanists pored over pressed herbarium specimens as part of a comprehensive restructuring of the entire cactus family. Nathaniel Lord Britton, former mining engineer and geologist, had turned to a career in botany and married Elizabeth Gertrude Knight, also a botanist. The couple founded the New York Botanical Garden, of which Nathaniel became head. It was a small world in botany in those days; Britton and D. T. MacDougal were at one time colleagues at the Botanical Garden, before MacDougal left to head the Desert Lab in Tucson.

Nathaniel Britton was working with Dr. Joseph Nelson Rose of the United States National Herbarium and, at the urging of MacDougal, Britton and Rose expanded their cactus work. They made trips into Mexico and South America, reexamined all the type specimens and original descriptions of cacti, and assembled large collections for greenhouses and herbaria. From 1914 to 1923, Britton and Rose completed their definitive four-volume publication, *The Cactaceae.*

One botanist who was undoubtedly familiar with their work was Elzada Clover, professor at the University of Michigan at Ann Arbor. During a trip to southern Utah in 1937, Clover met an enterprising river man named Norm Nevills at the crossroads of Mexican Hat. She enlisted his services to manufacture the boats and guide her down the Green and Colorado rivers on the Colorado Plateau. Clover's main goal was to study the region's plant life, especially the cacti, which were her specialty.

With Nevills eager and willing to make the trip, Elzada returned to Ann Arbor and assembled a crew, among them a young graduate student in botany, Lois Jotter. In three wooden boats built by Nevills, the trip launched from Green River, Utah, in June 1938. The *Detroit Free Press* headlined an article on the launch, "Two Flora-Minded Women Off On Daring Boat Trip."

The trip *was* daring in those days, for only a handful of people had boated that entire stretch of wilderness whitewater. The group had a wild run through

A forest of cardon cacti (Pachycereus pringlei) on Isla Cholludo, a tiny island in the Sea of Cortez. This island, untouched by human habitation, supports a veritable garden of cacti. The thick trunks of cardons led to the genus name, Pachycereus, from the Greek word pachys, meaning thick. The other cardon species in Baja California is Pachycereus pecten-aboriginum.

Cataract Canyon in late June, when the Colorado was in flood. Strenuous boating, some injuries and minor illness, summer heat, and exhaustion took their toll on everyone's strength and morale. Yet as befitted women of their era, Clover and Jotter obliged to cook all the meals for the male crew, gathering plants when they could and pressing specimens late into the night. Though the manner of travel prevented collecting great quantities of bulky cacti, the two women did manage to stow many specimens in watertight hatches on the boats. After eighteen days, the trip arrived at Lees Ferry, at the head of the Grand Canyon. They were a few days late, and the press had engaged in a flurry of speculation that disaster had befallen the adventurers. Though two crew members left the trip at Lees Ferry, Clover and Jotter were determined to go all the way through the Grand Canyon. As they proceeded downriver, Elzada noted the change in plants as they went deeper into the desert, especially the increasing size of the barrel cacti. Upon their arrival at Boulder (Hoover) Dam at the head of Lake Mead on August 1, they had traveled 666 miles in forty-two days.

Clover bid a sad farewell to the river and her friends but declared the trip "more successful than we had dreamed." She and Jotter published their findings in two major papers in 1941 and 1944. In the first report they described three new species of cacti from the Grand Canyon and one from upstream in Glen Canyon. In addition to their significant cactus collections, they made history as the first women to successfully complete a run on the Colorado River through the Grand Canyon.

Cactus exploration has continued unabated throughout this century. The excursions of George Lindsay into Baja California and Werner Rauh's detailed studies in North and South America deserve mention. Dr. Helia Bravo-Hollis, Mexico's "first lady of cactus," produced the four-volume *Las Cactaceas de Mexico*, a monument to a life's career among that country's amazing cacti. Her coauthor on one volume was the late Hernando Sanchez-Mejorada. The late Lyman Benson also was among the greatest contributors to our knowledge of the cactus family.

Scientists and amateurs alike are still exploring in Mexico and Central and South America, combing the countryside for new species, which they continue to discover and describe. The cactus chronicles have by no means come to an end.

Pitaya agria *cacti* (Stenocereus gummosus) *grow from a carpet of sand verbena and poppies in February in the Vizcaino Biosphere Reserve in central Baja California. The sour pitaya's sprawling habit has also given it the common name "galloping cactus." Native fishermen threw the branches of* pitaya agria *into the sea to stun fish.*

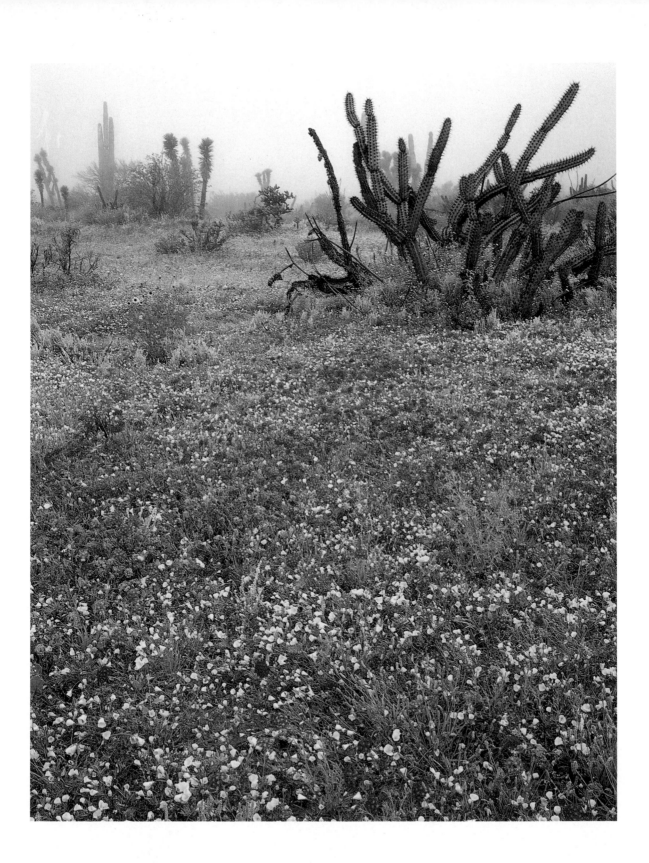

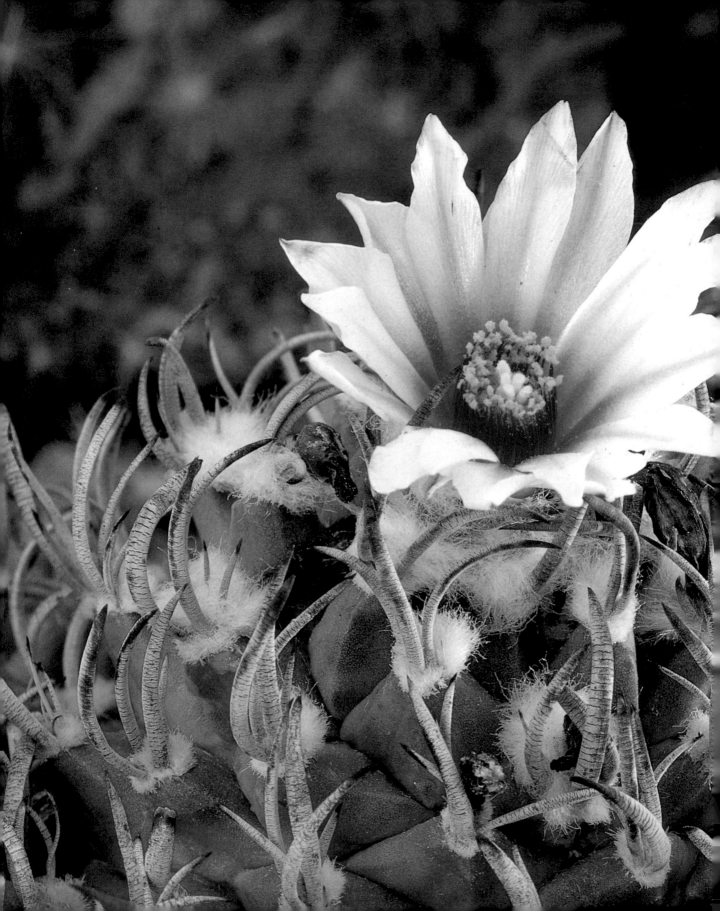

HUMAN IMPACT AND
CACTUS CONSERVATION

Disappear-
ing Acts

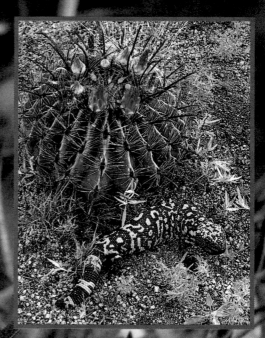

Disappearing Acts

ON A BEAUTIFUL SPRING MORNING, Edward Anderson sat in his office in the Desert Botanical Garden in Phoenix, Arizona, surrounded by books and boxes. He was getting ready to head out to the Big Bend region of west Texas to check on the status of another, possibly endangered cactus.

For more than thirty years, Anderson has kept tabs on rare cacti. What he has seen is not always a happy story. Collecting by individual hobbyists and commercial dealers, along with accelerating destruction of habitat, are the two main causes of decline of cacti everywhere.

With regret in his voice, Anderson told of a place in Mexico he visited in 1961, a hill where cacti were so thick a person could not walk without stepping on them. Three years later, he returned to the same hill and found almost no cacti left. Collectors had gotten wind of the site and in that short time had wiped out the entire population.

Discouraging tales such as this abound: Lindsay's cactus, an echinocereus, was only discovered in 1975. When collectors learned of the location beside a road in Baja California, all the plants were removed within five years. Because that was then the only place where Lindsay's cactus was known, the species was declared extinct in the wild. Although a few others were found later, in 1994 an intensive search by experts of this plant's known habitat turned up no specimens. The initial declaration of extinction may turn out to be the correct one. So we learn the sad fact that Lindsay's cactus is likely gone forever from its native land—solely because collectors wanted it for personal, selfish reasons.

Private and commercial collecting, especially in Mexico, has imperiled many wild cacti. World Wildlife Fund president William K. Reilly declared in 1987 that "Overharvesting for commercial trade is the single greatest threat to many of the world's rare and endangered cacti." The Fund, which monitors traffic in endangered plants and animals, has estimated that 20,000 rare and endangered Mexican cacti are smuggled across the border into the United States each year. Though such estimates obviously are at best educated guesses, cactus pilfering remains a dire problem.

PRECEDING PAGES: Turbi-nicarpus schmiedickeanus *var.* schmiedickeanus. INSET: *Barrel cactus (Fero-cactus wislizeni) with gila monster.* ABOVE: *Immature red-tailed hawk perched on a saguaro (Carnegiea gigantea).* OPPOSITE: *Flowers of the living rock cactus (Ario-carpus retusus), a rare species of Mexico's Chihua-huan Desert. Living rock cacti are in high demand among cactus collectors; until recently many were collected in the field and exported from Mexico by the hundreds of thousands.*

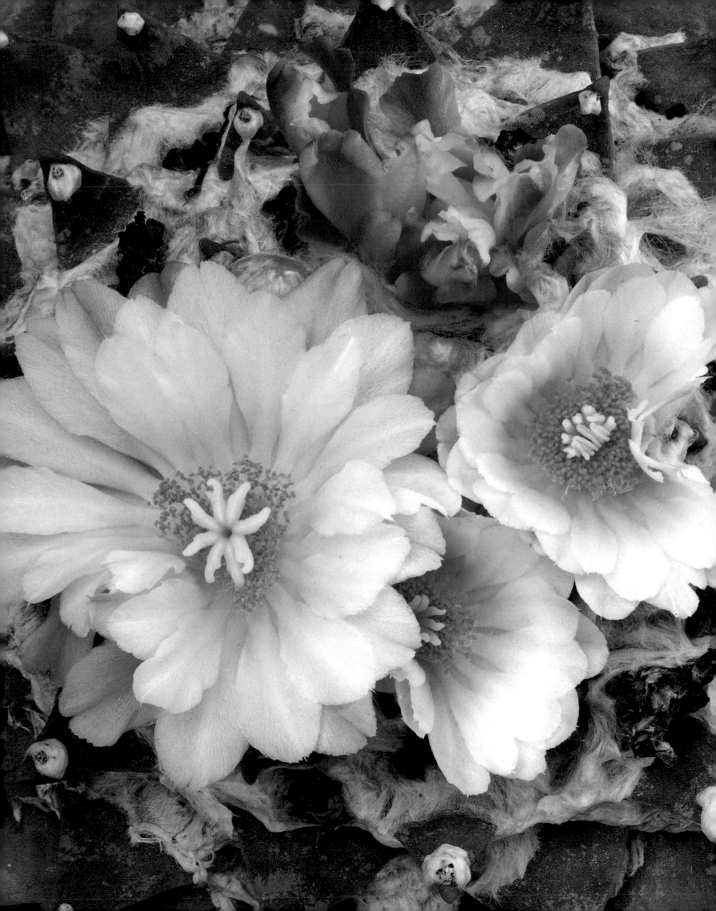

Beautiful and unusual cacti are coveted by collectors all over the world, especially in Japan, Germany, Britain, and the United States. For some, the rarer and odder the plant the better. Others want wild cacti because they possess a rugged "natural" look, and because some species grow too slowly or are difficult to cultivate.

Although laws and treaties to protect cacti in the wild have been in force for more than two decades, illegal collecting still occurs, evidenced by reports of local residents, diggings botanists see in the field, and cases uncovered by authorities. Living rock cacti, so named because they look strikingly like their stony surroundings, are in high demand these days. These include species of *Ariocarpus* and one called *Aztekium ritteri.* The Aztec cactus grows only on extremely rugged cliffs in one known location; the difficult access has not deterred ambitious collectors, who resort to poles and ropes to reach the plants. Such determined collecting has nearly extinguished these cacti in their native habitat.

A seemingly optimistic trend—use of cacti as landscaping plants in desert areas—is another source of trouble. A few unscrupulous dealers are stealing full-grown specimens from the desert in clandestine nighttime activities. It's a lucrative business—a twenty-foot-tall saguaro with a couple of arms can be worth a thousand dollars on the black market. Fortunately, the trend may be coming to a halt as "cactus cops" step up efforts to nab these thieves. In 1990, after a four-year investigation, twenty-one people were sentenced to jail and fined $5,000 to $12,000 for stealing and selling thousands of saguaros and barrel cacti from public lands in Arizona. The convictions sent a strong message to potential violators that cactus poaching will not be ignored.

Regulation of international collecting and trade of cacti centers on one significant treaty called the Convention on International Trade in Endangered Species —CITES for short. More than one hundred countries have signed on to CITES since it was instituted in 1973.

The heart of CITES is a permit system which applies to plants listed in the treaty's appendices. A number of cacti are listed specifically in Appendix I, which has the tightest restrictions. A plant is listed in Appendix I if it is in danger of extinction; no commercial trade in these species is allowed. In addition, the entire family of Cactaceae is listed in Appendix II, which includes plants threatened with extinction if trade is not regulated. Representatives from CITES countries meet each year to review and vote on species to be added or removed from the lists.

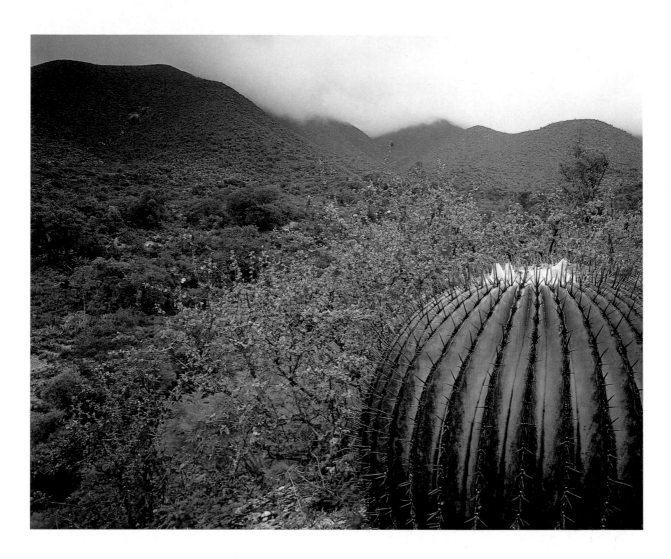

Biznaga de dulce, *or candy barrel cactus (Echinocactus ingens), is surrounded with pink cliffrose in the foothills of Mexico's Sierra Madre Orientale. In some cases, barrel cacti collected for candy making have become scarce near towns and cities.*

The United States Department of Agriculture's Animal and Plant Health Inspection Service (APHIS) is in charge of plant inspections at fifteen entry ports on the United States border. APHIS agents check primarily for disease and insects, but also for proper permits and correct documentation of plants entering and leaving the country. As one agent noted, "many people haven't heard of CITES until they try to move a plant."

Although CITES is the most promising tool in the international arena to protect rare cacti, enforcement has been a weakness. For the first ten years, CITES enforcers focused more on illegal trade of endangered animals—leopards, alligators, and other "glamour" creatures. The courts, too, have not always viewed plant

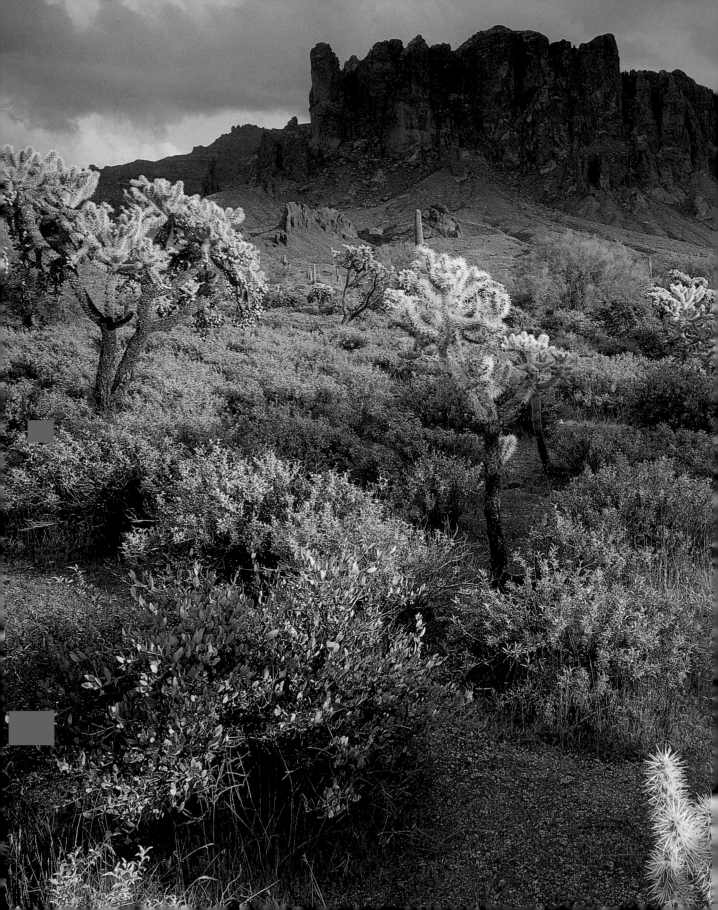

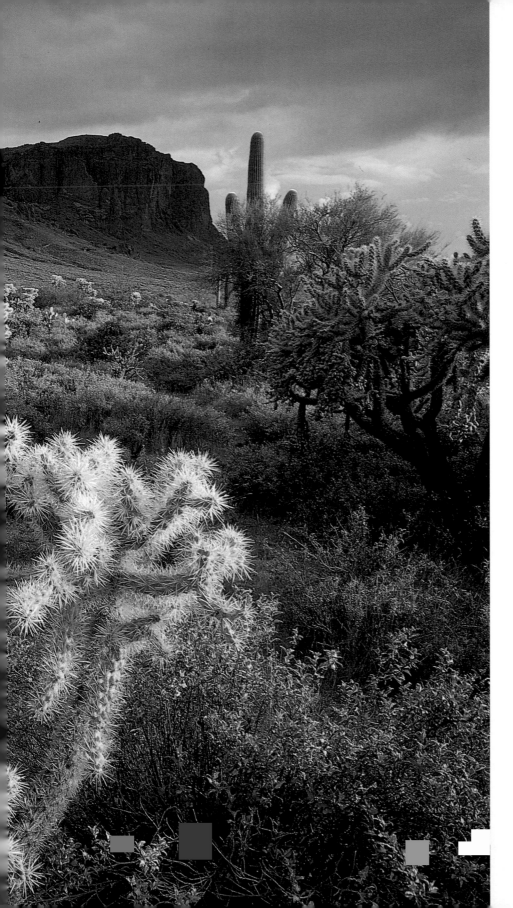

Unlike most cacti, cholla are normally not harmed by activities such as livestock grazing. These jumping chollas (Opuntia fulgida) are protected in Lost Dutchman State Park in the Superstition Mountains in Arizona.

poaching as a serious offense. Enforcement is made more difficult because importers sometimes make improper declarations and intentionally misidentify cacti; this leaves it up to APHIS inspectors, who are often not trained botanists, to determine if the plant is correctly identified. In addition, wild plants are often tough to distinguish from artificially propagated ones. Even with the most rigorous enforcement, clever smugglers can prove intractable foes.

Agents launched a crackdown on illegal plant commerce in the mid-1980s, and cacti were one of their first targets. In 1986, a United States Fish and Wildlife Service agent posed as a cactus collector in several southern California nurseries. His discoveries led to seizure of more than two hundred of the famed living rock cacti, along with indictments against the accused importers.

The good news is that Mexico signed onto CITES in 1992. Now nearly everyone, including scientists, finds it extremely difficult to obtain a permit to export cacti from Mexico. This, along with an overall shift to artificial propagation, probably accounts for the steady decline in imports from Mexico. If demand can be met by reasonably priced, artificially propagated cacti, then pressure on wild populations may decrease.

This living rock cactus (Ariocarpus fissuratus var. lloydii) is exceedingly rare in the wild. The plant's range is small, and collecting has brought it to the brink of extinction in most places. Other Ariocarpus are in danger because of destruction of their habitat in Mexico.

ONCE UPON A TIME the desert was home mostly to cacti. No longer. The desert has been discovered; the Sunbelt is fast becoming home to more and more people, with their houses, fields, shopping centers, pipelines, oil wells, quarries, dams, cattle, sheep—reducing bit by bit the one thing that all cacti need—habitat. Destruction or "transformation" of habitat assumes many forms: overgrazing; woodcutting; off-road vehicles; urban, industrial, and agricultural development and often corresponding groundwater depletion; and indirectly, loss of pollinators. By United Nations' estimates, this kind of conversion of land, also called desertification, is affecting some fifteen million acres a year in semiarid parts of the world.

The Sonoran night-blooming cereus that grows along the United States-Mexico border reveals several sides of this trend. Searching for hours on the Mexican side of the border, ethnobotanist Gary Nabhan found, as he suspected, that livestock trampling and illegal trade have made this cactus a bit harder to find. But Nabhan also made another discovery. Woodcutters have taken out ironwood, mesquite, and palo verde trees essential to the germination of seeds of the cereus. The wood is being cut not only for firewood for local people, but also to satisfy the

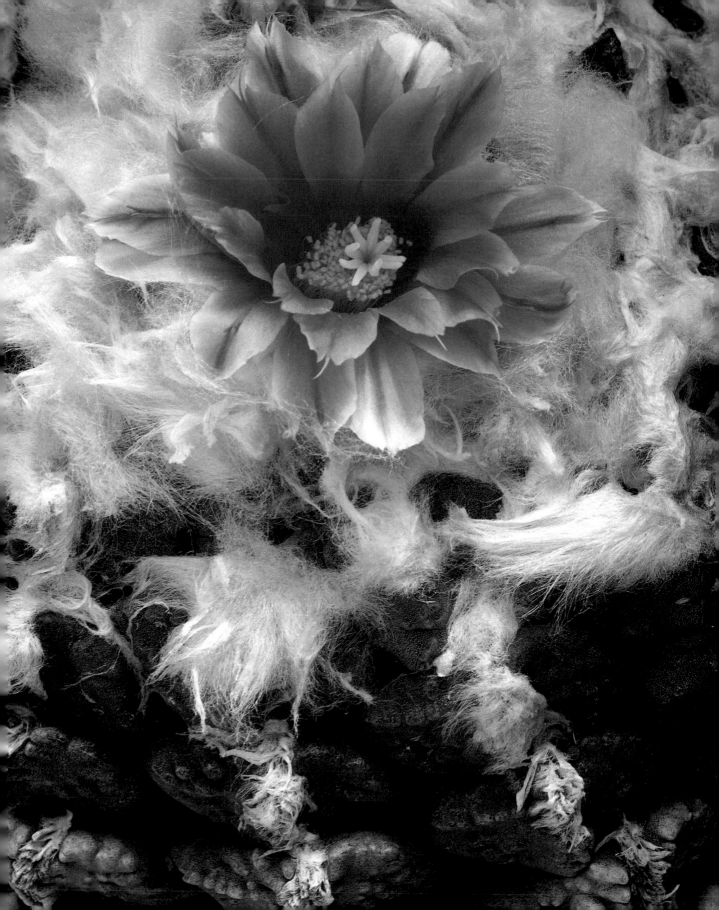

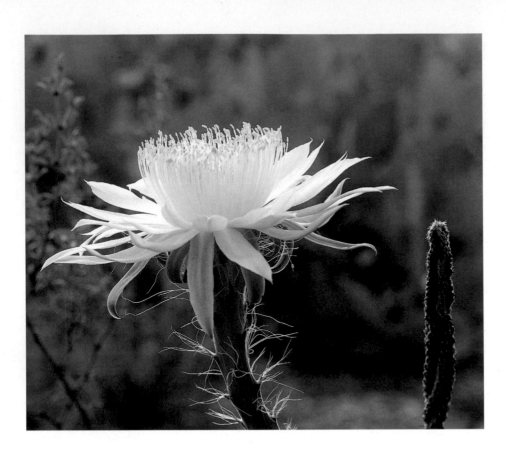

taste for mesquite-grilled meats north of the border. As the nurse plants are destroyed, Nabhan says, "night-bloomers and a variety of other cacti—from towering saguaros to picturesque pincushions—have been left without the camouflage of thorns and shade required to protect them." Without that umbrella, there could eventually be no night-blooming cereus, no cause for celebration on those summer nights when their blossoms shine like beacons of hope for these exquisite plants.

Most plants, including cacti, require pollination to set fruit and seed and hence perpetuate the species. The coevolution of animal pollinators and their flowers has taken millions of years to develop. As we continue tinkering with the environment, those fine-tuned, mutual relationships are being disrupted, often unknowingly. For many species of cacti, we are only beginning to know what insect, bat, or bee performs this essential role. Once we find out, then we must assure that the pollinators are not being eliminated and that they have something to pollinate.

Again, the night-blooming cereus provides a case in point. White-lined sphinx moths visit the nocturnal flowers and perform the vital service of pollination.

LEFT: *Although not legally an endangered species, the night-blooming cereus* (Peniocereus greggii) *has been losing critical nurse trees to woodcutters. As habitat becomes fragmented, this cactus may also suffer from a lack of flowers close enough together for sphinx moths to pollinate.* OPPOSITE: *Some of the most extensive stands of saguaro cacti* (Carnegiea gigantea) *in the world are protected within the 130-square-mile Saguaro National Park around Tucson, Arizona.*

Sphinx moth larvae also frequent adjoining irrigated farmlands. To get rid of them, farmers spray pesticides, coincidentally when the cereus are in bloom, thus doing away with a potential pool of pollinators. To complicate matters, a moth needs several flowers within reachable distance. If the plants' habitat is patchy and flowers aren't within range, the moth will have nothing to pollinate.

For organ pipe, cardon, and to some extent saguaro, lesser long-nosed bats are prime pollinators. The bats nuzzle into nectar pools deep in the funnel-shaped flowers, accumulating a heavy dusting of pollen around their noses in the process. As the bats travel from flower to flower on their nocturnal forays, they transfer the pollen, which allows the cactus to set fruit and form seed. The lesser long-nosed bat is now listed as endangered in the United States. Its decline could affect the chances of survival for these cacti, if other pollinators weren't waiting in the wings to assume the role.

The munchings and tramplings of livestock have long been known to harm some cacti. One victim may be the grama grass cactus, once numerous but show-

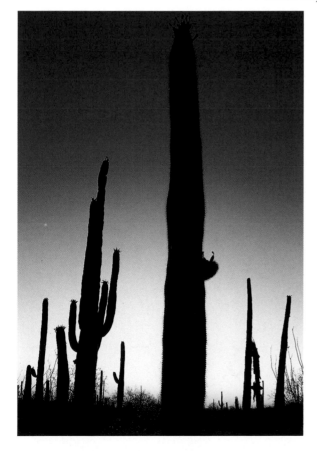

ing a definite downturn in recent years. This plant "hides" among rings of grama grass on rangeland in Arizona and New Mexico; its papery, light-colored spines look so much like the grass that rodents can't find the cactus and eat it. As cattle and sheep eat away this grassy shield, however, this cactus is deprived of that protective cover.

A complex combination of collecting and habitat destruction has affected the peyote cactus. For more than a century, people in south Texas, called *peyoteros,* have gathered peyote for sale to members of the Native American Church for their religion. *Peyoteros* pay a fee to the federal government for a license to engage in this legal harvest, and they pay for leases to gather on private lands. Nearly two million peyote "tops" are collected annually by about a dozen active *peyoteros.* This amount, however, falls far short of the five to ten million the Native American Church says it would use each year.

Botanist Edward Anderson, who has devoted a great deal of time to studying peyote, is concerned that such huge demand could threaten the existence of peyote in the wild. Ironically, he says, that threat is not due directly to the *peyotero* harvest, for they carefully dig only the tops of the plants, leaving the root systems in place so the plants can regrow. Instead, Anderson sees two more serious problems.

One is an agricultural practice known as root plowing, which is done to increase rangeland for cattle. This plowing uproots and destroys nearly all native plants on a piece of land, including peyote. Second, private landowners simply are closing off their property to *peyoteros,* which puts greater pressure on lands where peyote can be harvested legally. "The long-term prognosis, if present conditions continue to exist, is grim," says Anderson.

He would like to see ranch owners persuaded to let carefully supervised, legal harvesting take place on their lands. Anderson also suggests that whole peyote plants be salvaged before root plowing takes place, so peyote can be cultivated elsewhere. In addition, dried peyote could be imported from Mexico, where it grows more abundantly, but it is a protected species there.

The Endangered Species Act, a landmark law in the United States, is one of the world's greatest hopes for saving cacti. The act lists animals and plants as endangered or threatened, forbids harm to those species, restricts interstate trade, and calls for plans to recover populations to safe numbers. Sadly, cacti represent a disproportionate share of the plants listed. Nearly twenty cactus species are endangered—they are in imminent danger of extinction; a number of others are threatened—they will graduate to endangered if the status quo continues; several more are candidates for listing, but money and personnel are not always available to determine their actual status.

Among the endangered ones are several species in the genus *Pediocactus,* including Knowlton's cactus, Peebles Navajo cactus, Brady pincushion, and the San Rafael cactus. These shy, retiring plants are rare by nature and picky in their environmental needs. *Pediocactus* are famous for their habit of retracting under-

BELOW: *Although this species of peyote* (Lophophora diffusa) *does not contain hallucinogens, its restricted range and popularity among collectors have made it extremely rare. Demand for peyote is fueled by the fact that, except for members of the Native American Church, cultivation and possession are illegal in the United States.* OPPOSITE: *The hatchet cactus* (Pelecyphora aselliformis), *shown here more than twice actual size, has always been rare. Overcollecting, along with home construction, road building, and mining, threaten its existence in the wild.*

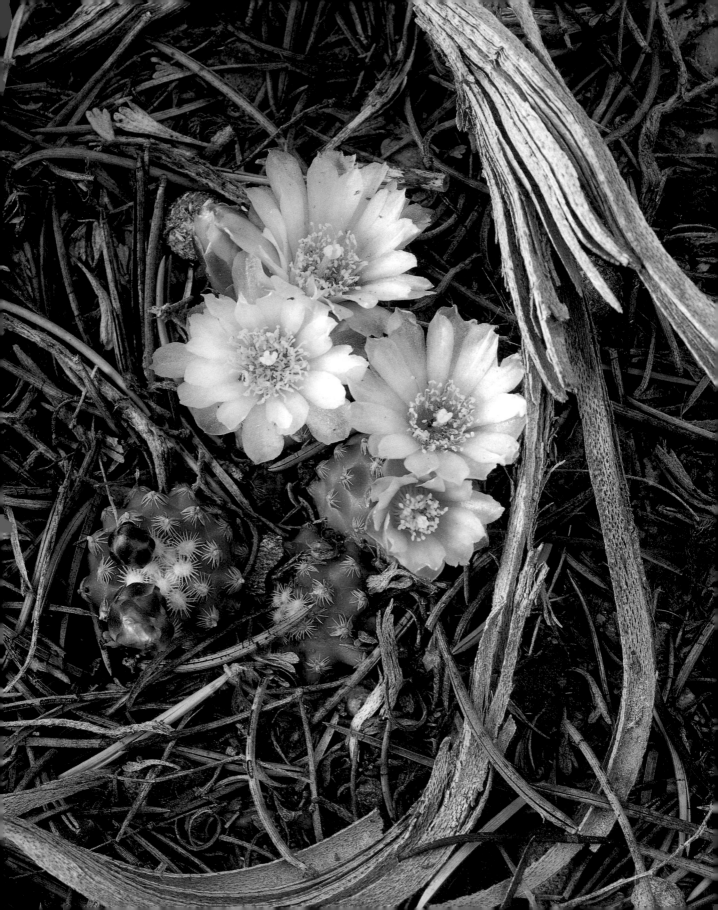

ground during dry times. Most grow on the sparse, rocky soils in the Four Corners region of the Colorado Plateau. According to the World Wildlife Fund, collectors reportedly "make the rounds" through the Four Corners, assembling entire sets of these highly desired cactus.

Peebles Navajo cactus grows in one county in northern Arizona, on a strip of land about seven miles long and a mile wide. The biggest threats to this cactus have been collecting, abuse of the environment, off-road vehicles, pack rats, gophers, and cattle. Residential development also poses a threat. In 1987, nearly a thousand individual plants were documented, and continued monitoring shows there is hope for the survival of the species. Because plant numbers vary widely from site to site and from year to year, long-term monitoring is essential.

The plants are so small scientists often have to get down on their hands and knees to locate them. Even after succeeding in finding specimens of Peebles Navajo cactus, one researcher was hindered by the activities of a native denizen. The researcher marked the cactus sites with red surveyor flags. Returning later, she found the flags were gone. A search of the surroundings revealed the culprit—the flags were stockpiled in a pack rat nest.

Knowlton's cactus is a tiny *Pediocactus* about an inch high and an inch in diameter. It is found only on a single hill near the New Mexico-Colorado border, the smallest range of any cactus species in the United States. Once there were several thousand of them, but collectors reduced Knowlton's to a few thousand plants. Fortunately, Public Service Company of New Mexico sold the land on which this population grows to The Nature Conservancy, and the plants have rebounded dra-

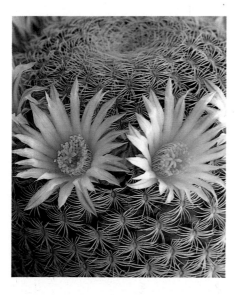

matically with protection. Recovery efforts include transplanting Knowlton's to other sites, but reproduction has not yet occurred in any great numbers.

A number of hedgehog cacti have also earned the dubious distinction of being listed as endangered. Davis's green pitaya, Lloyd's, Kuenzler's, black lace, spineless, Arizona, and Chisos Mountain hedgehogs could vanish from the face of the earth in the absence of measures to save them. Kuenzler's hedgehog, found in southern New Mexico, is the rarest cactus known in that state. Collection has spelled its demise, although protective steps and large-scale propagation efforts could turn that around. Davis's

green pitaya grows in grasslands near Marathon, Texas. Again, overzealous collectors have nearly sealed the fate of this cactus. Private landowners have fenced the area where Davis's grows, however, and the plant's numbers have stabilized and may be increasing.

Several *Coryphanthas* of the Chihuahuan Desert in west Texas and southern New Mexico are endangered or threatened. This group is popularly known as the pincushions, for their diminutive, bristly demeanor. One with the delightful name of Nellie cory bears lovely gray or pink, club-shaped spines. It is a real specialist, growing among mossy, weathered chips of a rock called novaculite. Such a beauty has long attracted commercial collectors, but luckily Nellie cory can be cultivated fairly easily, which may mean its salvation.

In south Florida and on the Keys, development has nearly spelled the end of two cereus cacti, the fragrant prickly-apple and the key tree cactus. The weak stems of fragrant prickly-apple lean among plants on sand dunes along the Atlantic coast. In May heavily scented, white or pink flowers bloom, and the plant bears big, red fruit. Housing and commercial development along the lagoon where prickly-apple grows has caused significant declines in the plant. Only a few hundred remain, and a single event, such as a bulldozer or determined collector passing through, could destroy these remnants.

The tall, slender key tree cactus is a spectacular plant that forms massive clumps. It grows on tropical hammocks, raised "islands" of dense, hardwood trees and shrubs surrounded by wetlands in the lower Florida Keys. The key tree cactus also grows in Cuba, and its problems there are the same as in Florida. With nearly all the hammocks bulldozed into oblivion, the key tree cactus teetered on the brink of extinction. One population is being managed on federal land, and additional clumps have been discovered, an example, says one Florida botanist, in which conservation efforts have made a difference. Both the key tree cactus and the fragrant prickly-apple are under cultivation at Fairchild Tropical Gardens in Miami, another measure that may help save these special plants.

At the other end of the country, in the southern San Joaquin Valley of California, the Bakersfield cactus is in peril. Once abundant, this prickly pear has been reduced to only a few isolated groups as land has been put under cotton and potatoes. The existing colonies of the Bakersfield cactus are threatened by oil and gas development, urban sprawl of its namesake city, and destruction caused by off-road vehicles.

Though the Endangered Species Act may be the greatest hope, various state and tribal laws provide another layer of protection for cacti. These laws regulate intrastate collecting and sale, and most apply only to public or tribal lands. Arizona's "cactus cops" enforce one of the toughest native plant laws in the country. A strict tagging system is in place, and a number of the state's cacti are so rare they can be removed from the wild only for scientific, educational, or preservation purposes.

Certainly legislation and better enforcement of existing laws will help save the lives of some of these cacti. One Fish and Wildlife Service botanist observed that enforcement will work best for the commercial trade. Still, he had to acknowledge that enforcement remains a "horrific" problem out in the wild.

Will there ever be enough laws, enough agents in the field and at the borders? Are there better ways to secure a place on the ark for these remarkable plants? The first line of defense is to protect cacti in their natural, wild homes. Acquiring land where rare cacti grow, and placing the land in parks or reserves, is the ideal. This action has the side benefit of helping not only the cacti, but also the bats and wrens and fruit flies and all the other creatures that depend upon them. Obviously such an approach requires money and political will, both of which are not always in abundant supply. Yet once we know which species are in trouble and what they need, we can often insure their existence not with great sacrifice but simply by showing a little sensitivity.

A backup strategy, a bright spot on the horizon, is artificial propagation. When people can buy a certain cactus for a nominal sum, the hope is they will be less prone to seek the wild version. Many cacti are now raised successfully from seed and by tissue culture. The Japanese, in particular, have become experts at propagating cacti from tissue culture and grafting. So while Japan is one of the biggest importers of cacti, it is also one of the largest exporters of propagated cacti, supplying several million plants each year.

A desert tortoise feasts on the fruit of a prickly pear (Opuntia phaecantha) *in southern Arizona. Desert tortoises are threatened, heightening the imperative to protect the cacti upon which they depend.*

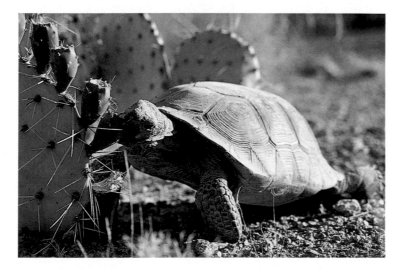

For scientific purposes, seeds and pollen of cacti are freeze-dried and held for later cultivation at botanical gardens and plant conservation centers. But raising cacti like animals in a zoo is a less than perfect solution. The plants' ecological requirements must be determined and then somehow mimicked under unnatural conditions. And a minimum number of plants of each species must be kept in a garden to assure healthy genetic variability. *Ex situ* conservation, as this strategy is called, may turn out to be practical only as a last-ditch effort on behalf of the most vulnerable cacti.

A senita cactus (Steno-cereus schottii) on Isla Datil in the Sea of Cortez. This island, protected by the Mexican government, now serves as refuge for senita and all the other members of the cactus clan.

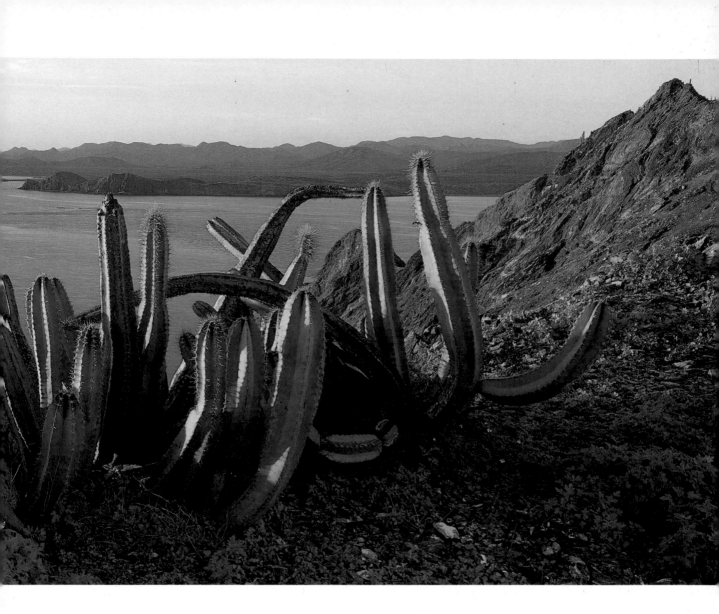

Education can also go a long way toward raising the consciousness of those who seek to add interesting cacti to personal collections. Education has definitely had a positive effect over the past decade in changing the hobby from a sort of "scavenger hunt" to one that emphasizes collectors' horticultural skills.

Still, as one botanist pointed out, we are always going to have to pay attention. For those cacti with limited distribution or numbers, and those that are slow growing and difficult to cultivate artificially, it could take only one event, natural or unnatural, to wipe them out forever. Such a fate would be a tragedy without remedy.

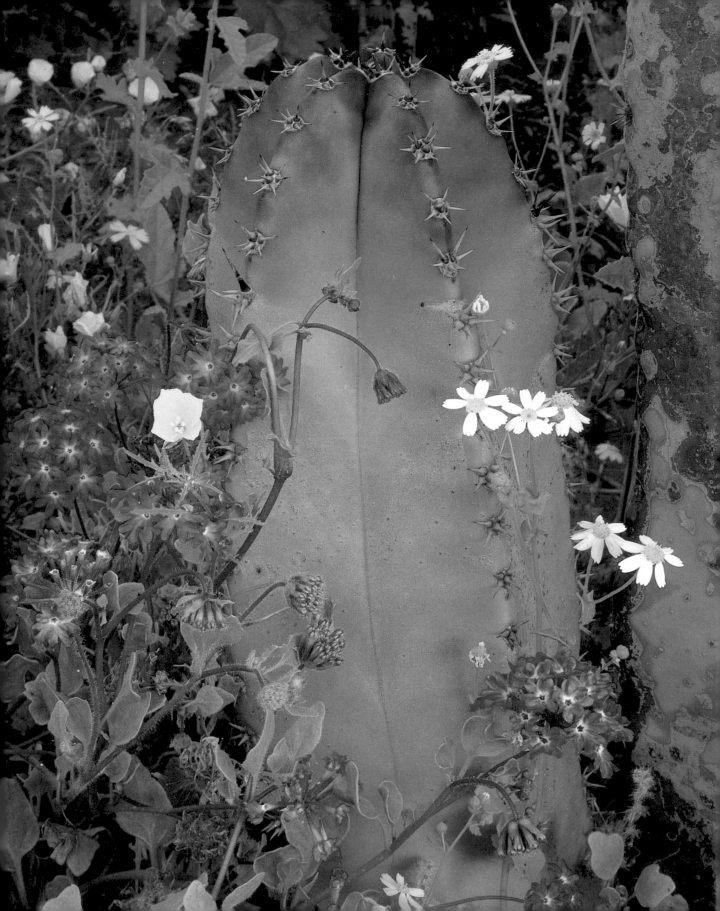

Growing Your Own

GROWING CACTI is an endlessly fascinating endeavor. Their enticing shapes, spine patterns, and gorgeous blossoms bring immense pleasure. For the home gardener, the excitement of nurturing cacti can evolve into a lifelong hobby.

Benign neglect may be the best way to describe proper care of cacti. In fact, it's possible to be too kind to them. The key is to try to duplicate the conditions of the plant's native habitat as closely as possible.

You don't need much in the way of special equipment to grow cacti: pots in graduated sizes, rubber gloves, tweezers, watering can, spoon or small trowel, sharp knife, commercial soil mix formulated for cactus, and spray bottles.

Following is a compilation of basic advice from expert cactus cultivators. Certainly others will know of techniques that have worked for them. Experience is the best long-term guide to growing your own cacti.

Transplanting

The quick and easy way to start a cactus collection is simply to buy a plant. Today you can buy cacti in the five-and-dime, in airport gift shops in the Southwest, and other places. But the best course is to purchase plants from a nursery specializing in cacti. The publications of cactus and succulent societies can lead you to reputable dealers. For beginners, nurseries can advise which cacti are easier to cultivate. Make sure the plant you buy is in good condition and that it was *not* collected in the wild.

Once home, transplant it. Knock the plant out of the nursery pot, keeping the roots damp. Have another pot ready, a size larger, which contains a layer of gravel in the bottom and soil mix specially made for cacti. Adding a little leaf mold, peat moss, or perlite to the mix helps drainage. You will need to wear gloves or hold the plant with a thick towel as you place it into the new pot.

Let the plant go two weeks without watering. To encourage growth, transplant the cactus each spring into a larger pot. Plastic pots have become popular, but others prefer clay because it allows evaporation to help prevent rot.

The beauty and appeal of cacti have inspired people all over the world to grow them in gardens, greenhouses, and on windowsills. With a few helpful hints to get started, cactus cultivation can become a lifelong pursuit. In some cases, nursery-raised plants have taken collecting pressure off rare species in the wild. Here, the often-cultivated senita cactus (Lophocereus schottii) stands amid sand verbena, daisies, and yellow poppies in Baja California.

Cuttings

As soon as the cactus bug has bitten, you will want to increase your collection. Fortunately, cacti are readily capable of vegetative reproduction, which also makes expansion of a collection inexpensive. To obtain a cutting, slice off a pad or joint at a node with a sharp knife. Dust the plant stem and the end of the cutting with hormone rooting powder that contains fungicide. Allow a day or two for a callus to form over the raw end of the cutting, then place it in a pot filled with potting mix. Water in two to four weeks, once roots have begun to develop. Another method: separate and pot the individual offshoots, or pups, that grow from the base of a mother plant.

Growing from Seed

To grow cacti from seeds, fill a flat seed tray with a loam, peat, and sand mixture covered with a thin layer of fine grit. Sow the tiny seeds over the surface; don't cover with dirt. Dampen the seeds and cover with a sheet of glass or plastic to hold in moisture until the seeds germinate. To mimic the "nurse" plant that cactus seeds need for germination in the wild, place the flat under a bench out of direct sun and at a constant temperature of 70 degrees Fahrenheit. Seedlings will need to develop for six months to a year before being transplanted into their own pots.

Grafting

Grafting involves attaching two cacti together so both will grow. A piece from one plant (the scion) is bonded to another rooted cactus (the stock) which supplies the food and water. In a basic flat graft, cut the stock horizontally with a clean, sharp knife. Lay the scion flat, take a slice off the base. Unlike a cutting, do not allow the ends to dry. Instead, immediately press the cut edges of the scion and stock together. For the graft to take, the rings of spots (vascular bundles) on each piece must touch or overlap. Attach the pieces with string or rubber bands, cover with a bag to retain humidity and warmth. In about three months, the scion should show signs of growth, if the graft worked. Grafting is best done in warmer months.

Caring for Cacti

Light is the single most important element in assuring healthy cactus plants, so where you grow your plants is critical. A hot, sunny windowsill indoors works very well. Or, should you become extremely involved in cultivating cacti, you may wish to graduate to a greenhouse. Strong light is also needed for the best blooms, the crowning glory for many cactophiles.

Watering is the second major consideration. Because cacti are desert plants, some people assume they can live totally without water. This is a myth. On the other hand, novice growers may tend to overwater. Experts recommend watching your plants, testing the soil for moisture, and watering only when the soil is dry.

During the growing period, from spring into early fall, water slowly in the beginning, let the soil nearly (but not totally) dry out, then increase watering to about once a week. Some people put their plants

outside during summer, so they can receive maximum light and air. Fertilize with each watering during the growing season. Fertilizer high in potash is recommended (one grower uses a 10-10-5 in solution). Run water through the soil several times to leach out any excess salts or fertilizer that may build up.

From October through March or so, let the cacti enter a natural winter dormancy. Do not water or fertilize during this period. In places where freezes occur, bring the plants back indoors to that sunny windowsill or into the greenhouse.

Pests
Mealybugs, aphids, red spider mites, scale, nematodes, ants, white flies, and some fungi, bacteria, and viruses can attack cacti. To ward them off, spray plants once a month during the growing season, and once or twice during dormancy, with insecticide and fungicide. Exercise caution with these, spraying plants outside on a still day. Follow label instructions closely, and use the same spray bottle each time. If you lean toward organic pest control, one grower recommends an alcohol spray on mealybugs, a wash of tepid water for red spider mites, and castor oil for scale and nematodes, which infect the soil and roots.

Books
A number of good books exist on cactus propagation and cultivation. Recommended for beginners is *The Instant Guide to Healthy Cacti* by John Pilbeam, Times Books, 1984.

Pronunciation Guide

bisnaga: biz-NAH-gah

cardon: car-DOHN

cereus: SER-i-ous

cholla: CHOY-ya

opuntia: o-PUN-chia

peyote: pay-O-tee

pitaya: pi-TIE-ya

saguaro: sa-WAR-o

senita: sa-NEE-ta

Select Sources

Abbey, Edward and editors of Time-Life Books. *Cactus Country*. Time-Life Books, Alexandria, Va. 1973.

Alcock, John. *Sonoran Desert Summer*. University of Arizona Press, Tucson. 1990.

Anderson, Edward F. et al. *Threatened Cacti of Mexico*. Royal Botanic Gardens, Kew, England. 1994.

Benson, Lyman. *The Cacti of Arizona* (3rd edition). University of Arizona Press, Tucson. 1969.

_____. *The Native Cacti of California*. Stanford University Press, Stanford, Calif. 1969.

_____. *The Cacti of the United States and Canada*. Stanford University Press, Stanford, Calif. 1982.

Bonker, Frances and John James Thornber. *The Sage of the Desert*. The Stratford Company, Boston. 1930.

Felger, Richard Stephen and Mary Beck Moser. *People of the Desert and Sea: Ethnobotany of the Seri Indians*. University of Arizona Press, Tucson. 1985.

Fischer, Pierre. *70 Common Cacti of the Southwest*. Southwest Parks and Monuments Association, Tucson. 1989.

Heil, Kenneth D. *Familiar Cacti*. Audubon Society Pocket Guides. Alfred A. Knopf, New York. 1993.

Johnson, William Weber and editors of Time-Life Books. *Baja California*. Time-Life Books, Alexandria, Va. 1971, rev. 1977.

McKelvey, Susan Delano. *Botanical Exploration of the Trans-Mississippi West, 1790–1850*. Arnold Arboretum, Jamaica Plain, Mass. 1955.

Moseley, Charles J., editor. *The Official World Wildlife Fund Guide to Endangered Species of North America*. Beacham Publishing, Washington, D.C. 1992.

Nabhan, Gary Paul. *Saguaro: A View of Saguaro National Monument & the Tucson Basin*. Southwest Parks and Monuments Association, Tucson. 1986.

_____. *Gathering the Desert*. University of Arizona Press, Tucson. 1985.

_____. *The Desert Smells Like Rain*. North Point Press, San Francisco. 1982.

Niehaus, Theodore F. *A Field Guide to Southwestern and Texas Wildflowers*. Houghton Mifflin, Boston. 1984.

Perl, Philip and editors of Time-Life Books. *Cacti and Succulents*. Time-Life Books, Alexandria, Va. 1978.

Pizzetti, Mariella. *Guide to Cacti and Succulents*. Simon & Schuster, New York. 1985.

Thornber, John James and Frances Bonker, *The Fantastic Clan: The Cactus Family*. Macmillan, New York. 1932.

Wenger, Del. *Cacti of Texas and Neighboring States*. University of Texas Press, Austin. 1991.

Zwinger, Ann. *A Desert Country Near the Sea: A Natural History of the Cape Region of Baja California*. Harper & Row, New York. 1983.

Other sources included various issues of *Agave* magazine, published by the Desert Botanical Garden in Phoenix, Arizona; *Desert Plants* magazine of the Boyce-Thompson Arboretum, Superior, Arizona; and the *Cactus and Succulent Journal*, the bimonthly publication of the Cactus & Succulent Society of America, headquartered in Des Moines, Iowa.

Acknowledgments

The photographer and author extend gratitude to
many people who generously gave of their time and
knowledge for this book: Ken Heil, Marilyn Heil,
and Gary Paul Nabhan reviewed the manuscript,
and Miles Anderson patiently confirmed species
identification on many of the photographs. Thanks
also to Edward Anderson and Jane Cole of the
Desert Botanical Garden, Bach's Cactus Nursery,
Russ Buhrow of Tohono Chul Park, Mark Dimmitt
of the Arizona-Sonora Desert Museum, and
T. J. Priehs of Southwest Parks and Monuments
Association. Others who helped in several ways
include Tad Pfister, Julian Hayden, Susie Smith,
John Anderson, Joel Floyd, Steven Brack, Mary
Jenkins, Kim Cliffton, Richard Felger, Clay May,
Bob Schmalzel, and Ferris Cook. Bernadette Rogus
contributed office assistance, and Christina Watkins
devoted efforts to developing the original concept
for this book. Botanists with a number of state,
federal, and private agencies shared information
and their deep dedication to protecting cacti.
Editor Jennie Bernard deserves praise for polishing
the prose. Designer Jim Wageman's artistic abilities
made this book a reality. Finally, sincere thanks
to Leslie Stoker at Artisan for her support and
encouragement throughout the process.

Index

Page numbers in *italic* refer to illustrations.

Ajo Mountains, *18–19, 74–75*

Anza-Borrego State Park, 7, *20, 23, 24–25,* 69, 86, 93

Areoles, 38, 41

Ariocarpus. See Living rock cactus

Artificial propagation, 115

Astrophytum myriostigma (Bishop's cap cactus), 46

Aztec cactus, 102

Aztekium ritteri, 102

Baja California, 7, *28–29,* 47, *59,* 61, 78, 79, 80, 81, *90–91, 92,* 96, 97, 100, *118*

Bakersfield cactus, 114

Barrel cactus (*Ferocactus*), 21, 22, 48, 66–68, *81,* 88, 93, 96

California (compass cactus) (*F. acanthodes*), *20,* 69, 86, 93

fishhook (*F. wislizeni*), *6,* 68, *84, 85,* 99

giant (*F. diguetii*), 47

Mexican fire (*F. pilosus*), 69

Barrel cactus (*Sclerocactus*), 21

Barrel cactus, candy. *See Biznaga de dulce*

Beavertail cactus (*Opuntia basilaris*), *6,* 21, 71

Beehive cactus (*Coryphantha vivipara*), 46

Bishop's cap cactus (*Astrophytum myriostigma*), 46

Biznaga de dulce (candy barrel cactus) (*Echinocactus ingens*), 50, 68, *103*

Britton, Nathaniel, 95

Cactus:

botanical exploration and, 76–96

cold temperatures and, 50–53

diverse growth habits of, 26–27

diversity of habit and range of, 15

ecological roles of, 31, 47–49

as food source, 56–63

growing, 119–21

human impact on, 110–17

medicinal uses of, 68–70

names of, 27–31, 76

origin of word, 38

origins of, 15, 31

spiritual uses of, 70–73

utilitarian products derived from, 63-68

water storage and conservation in, 43, 44–47

"Cactus belt," 15–26

Cactus wren, 47–48, *48*

California barrel cactus (compass cactus) (*Ferocactus acanthodes*), *20,* 69, 86, 93

Candy barrel cactus. *See Biznaga de dulce*

Cardon (*Pachycereus pringlei*), *26–27,* 44, 47, 48, *51, 59,* 67, 70, 78, 80, 92, *94,* 109

Carnegiea gigantea. See Saguaro

Cereus, 114

night-blooming (*Peniocereus greggii*), 37, 85, 106-9, *108*

Chihuahuan Desert, *1,* 15, 21, 23, 73, *101,* 114

Cholla (*Opuntia*), *6,* 15, 21, 38, 41, 44, 47–48, 63, 65, 70, 93

jumping (*O. fulgida*), *12, 18–19,* 41, 43, 48, *104–5*

teddy bear (*O. bigelovii*), *24–25,* 41, 47–48, *64,* 86

tree (*O. imbricata*), *45*

CITES, 102–6

Claret cup hedgehog cactus (*Echinocereus coccineus*), *21, 21,* 44, 46, *55*

Clover, Elzada, 95–96

Cochineal dye, 65–66

Collecting, 31, 34, 79–85, 100–106, 109–10, 113–14, 117

Compass cactus. *See* California barrel cactus

Coryphantha (pincushion cactus), 21, 79, 114

C. vivipara (beehive cactus), 46

Cuttings, 120

Davis's green pitaya, 113–14

Desert Botanical Laboratory, 88–95

Echinocactus:

E. horizonthalonius (eagle claw cactus), 23

E. ingens (biznaga de dulce; candy barrel cactus), 50, 68, *103*

Echinocereus. See Hedgehog cactus

Emory, William, 85–88

Endangered Species Act, 110–15

Engelmann, George, 79–82, 85, 88

Ex situ conservation, 116

Extinction, 100, 102

Fendler, Augustus, 82
Ferocactus. See Barrel cactus
Fishhook barrel cactus
(*Ferocactus wislizeni*), 6,
68, 84, 85, 99
Fishhook cactus (*Mammillaria microcarpa*), 16, 17
Flowers, 31, 38, 41–43
Fruit, 56, 59–63, 70, 85

Gambullos (*Myrtillocactus geometrizans*), 14, 34
Glochids, 41
Grafting, 120
Grama grass cactus, 109
Great Basin Desert, 15, 21
Gregg, Josiah, 85
Grizzly bear cactus (*Opuntia erinacea*), 46

Habitat destruction, 106–10
Hatchet cactus (*Pelecyphora aselliformis*), 111
Hedgehog cactus (*Echinocereus*), 7, 21, 23,
82, 82, 87, 113–14
claret cup (*E. coccineus*), 21,
44, 46, 55
Hinds, Richard Brinsley, 79
Hornaday, William, 88–93

Indian fig (*Opuntia ficus-indica*), 56–59
Isla Cholludo, 26–27, 67, 94
Isla Datil, 116–17
Isla Espiritu Santo, 6, 65
Isla Santa Catalina, 47

Jumping cholla (*Opuntia fulgida*), 12, 18–19, 41, 43,
48, 104–5
Jotter, Lois, 95–96

Key tree cactus, 114
Knowlton's cactus (*Pediocactus knowltonii*), 110, 112, 113
Kuenzler's hedgehog cactus, 113

Leaves, 44
Lindheimer, Ferdinand, 82
Lindsay's cactus, 100
Living rock cactus (*Ariocarpus*), 1, 21, 101, 102, 106, 107
Lophocereus schottii. See Senita
Lophophora. See Peyote
Lost Dutchman State Park,
104–5

MacDougal, Daniel T., 88–
93, 95
Mammillaria, 16, 70, 85
M. habniana (pincushion
cactus), 21, 23, 50
M. microcarpa (fishhook
cactus), 16, 17
M. solisioides, 113
Mexican fire barrel cactus
(*Ferocactus pilosus*), 69
Mojave Desert, 15, 21, 24–25
Myrtillocactus geometrizans
(*gambullos*), 14, 34

Native American Church, 73,
109
Nellie cory, 114
Nopales, 59
Nurse plants, 44, 45, 106–8,
120

Nuttall, Thomas, 76–79

Ocotillo, 13, 24–25, 38, 92
Old man cactus. *See* Senita
Opuntia, 41, 48, 50, 76, 79, 85
O. erinacea (grizzly bear
cactus), 46
see also Cholla; Prickly pear
cactus
Organ pipe cactus (*pitaya
dulce*) (*Stenocereus thurberi*), 12, 35, 40, 41, 48–
49, 59, 60, 61, 68, 75,
90–91, 93, 109
Organ Pipe Cactus National
Monument, 12, 68

Pachycereus pringlei. See
Cardon
Pediocactus, 21, 50, 110–13
P. knowltonii (Knowlton's
cactus), 110, 112, 113
Peebles Navajo cactus, 110,
113
Pelecyphora aselliformis
(hatchet cactus), 111
Peniocereus greggii (night-
blooming cereus), 37, 85,
106–9, 108
Pests, 121
Peyote (*Lophophora*), 21, 27,
72, 73, 109–10, 110
Photosynthesis, 47
Pincushion cactus
(*Coryphantha*), 114
Pincushion cactus (*Mammillaria habniana*), 21, 23, 50
Pitaya agria (*Stenocereus
gummosus*), 28–29, 32–33,
59, 59, 78, 90-91, 97

Pitaya dulce. See Organ pipe
 cactus
Pollination, 43, 108–9
Prickly-apple cactus, 114
Prickly pear cactus (*Opuntia*),
 15, 21, 41, 43, 44, 48, 56–
 59, 66, 70, 82, 85, 93
 beavertail (*O. basilaris*), 6,
 21, 71
 O. engelmannii, 5, 57, 82
 O. phaecantha, 10–11,
 13, 54–55, 56, 58, 115
 Santa Rita (*O. violacea* var.
 santa-rita), 16, 42
 Texas (*O. engelmannii* var.
 texana), 6, 11, 76, 83

Rainbow cactus, 38
Reina de la noche, 38, 39
Roots, 44–47
Rose, Joseph Nelson, 95

Saguaro (*Carnegiea gigantea*),
 2–3, 13, 15, 18–19, 26, 27,
 30, 41, 43, 44, 47, 48, 49,
 49, 52, 53, 59, 61–63, 62,
 64, 70, 74–75, 77, 88, 89,
 92, 100, 102, 109, 109
Saguaro National Park, 2–3,
 6, 13, 15, 53, 76, 109
San Pedro cactus, 70
Santa Rita prickly pear cactus
 (*Opuntia violacea* var.
 santa-rita), 16, 42
Sclerocactus (barrel cactus), 21
Sea of Cortez, 26-27, 47, 67,
 94, 116-17
Seedlings, 43–44
Seeds, 43, 61

growing cacti from, 115, 116,
 120
Senita (old man cactus)
 (*Lophocereus schottii*), 7, 12,
 38, 70, 92, 118
Senita (*Stenocereus schottii*),
 116-17
Shreve, Forrest, 15, 31, 41, 95
Sonoran Desert, 15, 15, 26,
 40, 61, 95
Spines, 38–41
Stenocereus:
 S. dumortieri, 36–37
 S. gummosus. See Pitaya agria
 S. schottii (senita), 116–17
 S. thurberi. See Organ pipe
 cactus
Superstition Mountains,
 82, 104–5

Teddy bear cholla (*Opuntia
 bigelovii*), 24–25, 41, 47–
 48, 64, 86
Texas prickly pear cactus
 (*Opuntia engelmannii* var.
 texana), 6, 11, 76, 83
Transplanting, 119
Tree cholla (*Opuntia imbri-
 cata*), 45
Turbinicarpus schmiedickeanus
 var. *schmiedickeanus*, 98-99

Vizcaino Biosphere
 Reserve, 97

Wislizenus, Frederick, 85

Zion National Park, 6, 71

DESIGNED BY JIM WAGEMAN

THE TYPEFACE USED IN THIS BOOK IS CENTAUR,
DESIGNED BY BRUCE ROGERS AND FREDERIC WARDE

PRINTED AND BOUND BY ARNOLDO MONDADORI
EDITORE, S.P.A., VERONA ITALY